MW00610898

THE
GREAT NORTHERN
RAILWAY
THROUGH TIME

DALE PETERKA

AMERICA
THROUGH TIME®
ADDING COLOR TO AMERICAN HISTORY

First published 2016

Copyright © Dale Peterka 2016

ISBN 978-1-63499-008-0

Typeset in Mrs Eaves XL Serif Narrow

Published by Arcadia Publishing by arrangement with Fonthill Media LLC
For all general information, please contact Arcadia Publishing:
Telephone: 843-853-2070
Fax: 843-853-0044
E-mail: sales@arcadiapublishing.com
For customer service and orders:
Toll-Free 1-888-313-2665

Visit us on the internet at www.arcadiapublishing.com

Printed and bound by CPI Group (UK) Ltd Croydon CR0 4YY

INTRODUCTION

Two hundred years ago, if you wanted to visit what came to be called the "Pacific Northwest," you had to go by canoe! Explorers Meriwether Lewis and William Clark paddled their canoes through Dakota, Montana, Idaho and Oregon in 1805. (Canadian explorer David Thompson had explored the area two years earlier.)

If you wanted to visit the Pacific Northwest in 1836—it was now being called "the Oregon Country"—you had to go by wagon. Presbyterian missionaries Marcus Whitman and Henry Spaulding established the first missions in the Northwest and brought the first wagon over the Continental Divide at South Pass, Wyoming. They also brought their wives—the first white women in the Northwest! Five years later, hundreds of wagon trains were following the tracks they had made. The route was dubbed "the Oregon Trail".

In 1861, the way to Oregon was by way of the steamboat. You "sailed" from the East Coast down to Panama on an ocean steamer, crossed the isthmus by rail, and then followed the West Coast by steamer up to California and Oregon. Or, if you came out to the Northwest from St. Louis, you "steamed" up the Missouri River as far as Fort Benton, Montana, where a series of waterfalls blocked further progress. To go farther, you followed the Mullan Road, a rugged path that had been scratched out over the mountains. At Fort Walla Walla on the Columbia, another steamboat took you down the river to Portland, Oregon.

The next improvement for travelers to the Northwest was the Northern Pacific Railroad, completed in 1883. When the rails arrived, local citizens thought they were in high cotton! In a matter of days, they could ride the train from Montana west to the Pacific Shore or east to "the States" in relative comfort! No more dangerous steamboat voyages or bumpy stagecoach rides! The railroad was the road of choice in the Northwest for the next sixty years.

The second railroad to arrive in the Northwest (1893) was the Great Northern. The new line shared the same origin as the N.P. (Minnesota) and the same destination (the Pacific shore), but it had a lower crossing of the mountains, a more direct route, and a faster schedule. Within a few years, the GN had captured the contract for carrying the mail. Hauling grain, fruit, lumber and silk quickly became the other sources of revenue. Daily passenger service was another source of revenue—and pride! The railroads all boasted of their passenger amenities.

All too soon, passenger trains in the U.S. began their decline. In 1908, Model "T" Fords began rolling off the assembly line in Detroit, and Americans hit the road in their own cars.

In 1925, Ford began building the first commercial airliner, the Tri-Motor.

In the 1950's, the arrival of the Interstate Highway System and the jet airliner signaled what everyone already knew: the Glory Days of Rail Travel were over. In 1971, after years of running in the red, the American railroads surrendered their passenger service to the National Rail Passenger Corporation—Amtrak.

In 1970, the Great Northern Railway merged with the Northern Pacific Railroad—and a few others!—to form the Burlington Northern, now the BNSF Railway. The Great Northern name disappeared, but the name of its premier passenger train, the *Empire Builder*, survived in the form of a shiny stainless steel Amtrak train that runs daily between Chicago and Seattle with a connection from Spokane to Portland.

This is the story of the Great Northern Railway, the *Empire Builder*, and the territory it called "home".

Photos by the author unless otherwise noted.

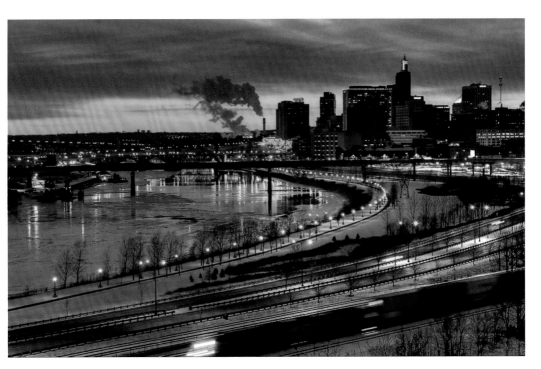

JAMES J. HILL ARRIVES IN ST. PAUL: The Great Northern story begins in St. Paul, Minnesota, where the young James J. Hill arrived in 1856. Hill quickly established himself as a coal wholesaler and shipper, and by 1876 he and his partners had bought their first railroad, the *St. Paul and Pacific*. By 1893, their railroad—renamed the Great Northern Railway—was running all the way to the Pacific Ocean. The enterprise was a success! When Hill died in 1916, he was worth $2.5 billion (in today's dollars). (*Travis Dewitz photo*)

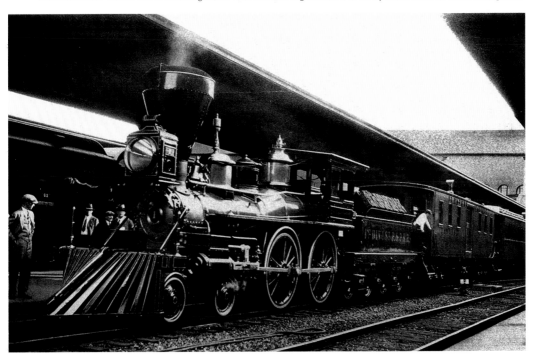

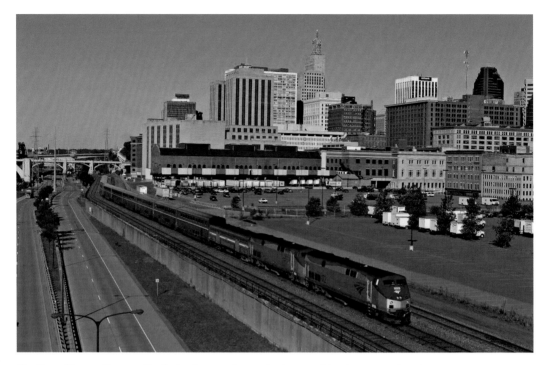

ST. PAUL UNION DEPOT: The St. Paul Union Depot, built in 1926 by the nine railroads serving the city, was a source of local pride for years. Closed in 1971, the structure sat virtually empty until 2013, when it took on new life with the installation of street car and bus service in downtown St. Paul. Today with a new name—the St. Paul Transportation Center—it welcomes the daily eastbound and westbound *Empire Builder* on the route between Chicago and Seattle. (*Steve Glischinski photo*)

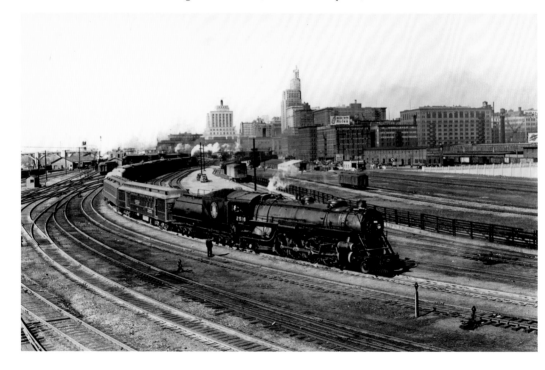

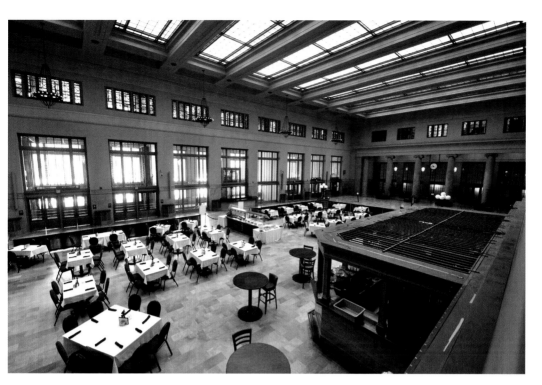

S.P.U.D.: The St. Paul Union Depot is located in the busy center of the Minnesota state capital with the business and entertainment district at its front door and the Mississippi River at its back. The depot rotunda has become a classy restaurant.

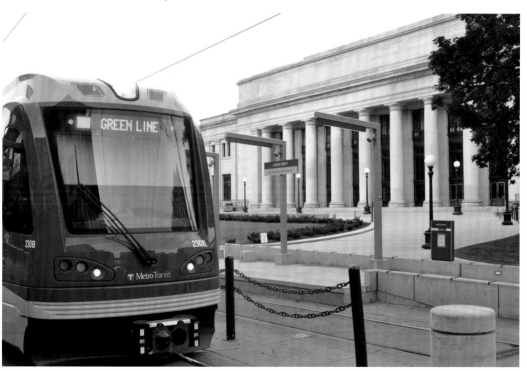

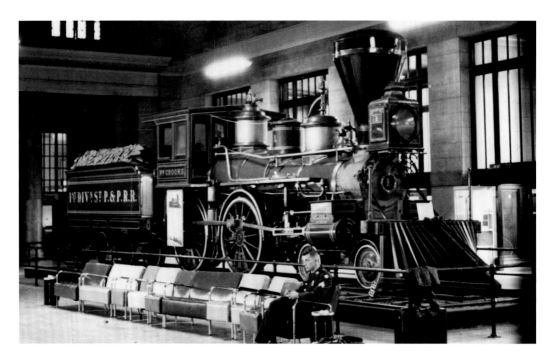

THE WILLIAM CROOKS LOCOMOTIVE: The first locomotive in the state of Minnesota was delivered by steamboat in 1861. A favorite of Mr. Hill, the *William Crooks* was preserved by the railroad and toured the line from Chicago to Seattle in 1924. The engine appeared at railroad exhibitions in Baltimore (1927), New York (1939) and Chicago (1947), each time making the journey under its own power. The *Crooks* was put on display in the rotunda of the St. Paul Union Depot in 1954. In 1975, it was donated to the Minnesota Historical Society and is now housed at the Lake Superior Railroad Museum in Duluth, Minnesota—in spotless condition! (*Skykomish Historical Society collection*)

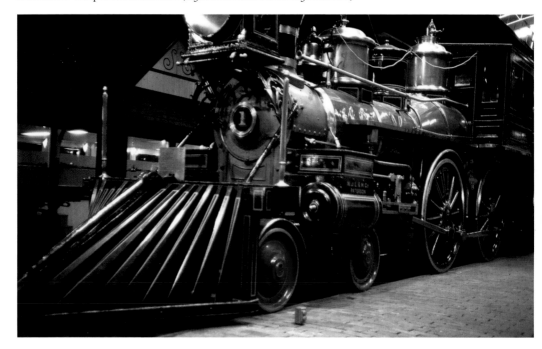

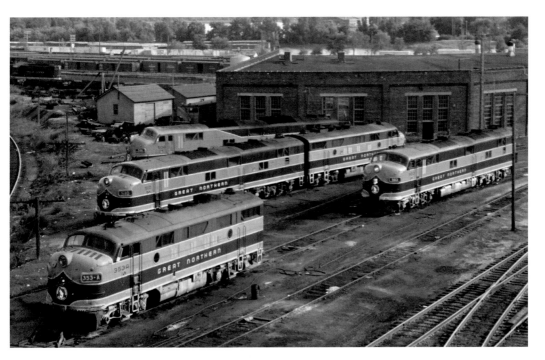

THREE MAINLINES MEET: St. Paul Junction is a small three-sided plot located in the bottom land east of St. Paul Union Depot. Here the rail lines from Chicago, Minneapolis and St. Paul meet. In a busier time, there was a small engine house on the site where engines were serviced after arriving in town with the region's classiest passenger trains. In the modern photo, restored Great Northern diesel #400 has backed out of Union Depot and is on its way to Stillwater, Minnesota, for summer excursion service. (*Roundhouse photo by Wallace Abbey from Center for Railroad Photography and Art; modern photo by Dan Kwarciany*)

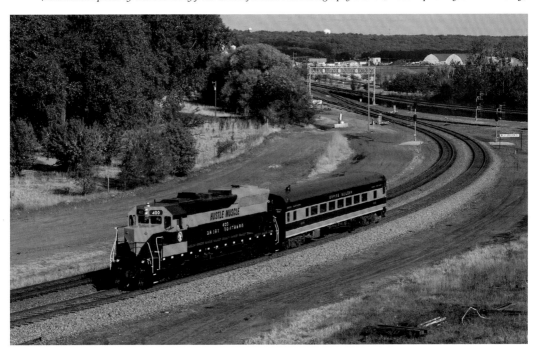

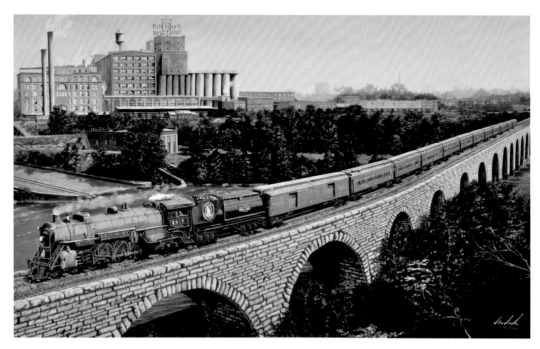

STONE ARCH BRIDGE: The Great Northern Stone Arch Bridge in Minneapolis, completed in 1883, carried rail traffic across the Mississippi River for ninety-five years. When proposed, the 2000-foot bridge was dubbed "Hill's Folly". When completed, it was the wonder of the age! Erosion of the foundations finally caused the bridge to be closed in 1978. Illustration shows the *Empire Builder* crossing the bridge in 1929. Today, the bridge carries bicyclists, hikers and wide-eyed tourists! Amtrak *Empire Builder*, shown in 1978, is using the equipment "inherited" from the various private railroads. The "dome cars" remained a feature of the *Builder* until 1980, when modern new cars began arriving from the Pullman Company. (*Illustration by James Jordan*)

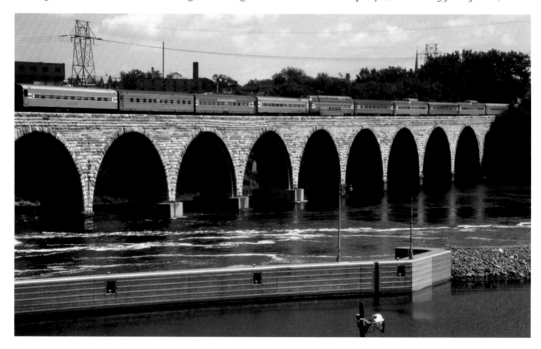

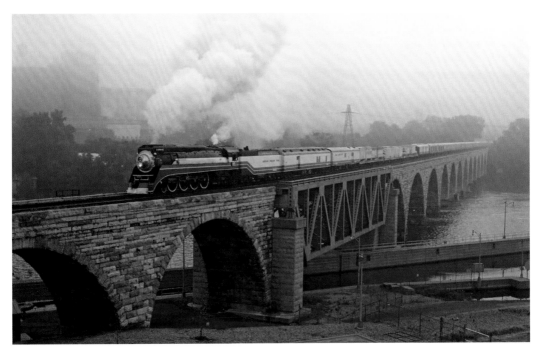

THE FREEDOM TRAIN: Shown on the Stone Arch Bridge in 1976, the Freedom Train visited every state in the "lower 48" and stopped in many cities for viewing of items of Americana. Among the items on display were an early hand-written copy of the constitution, the original Louisiana Purchase, the pulpit of Rev. Martin Luther King, Judy Garland's dress from *The Wizard of Oz*, and replicas of Jesse Owen's four gold medals. Steam locomotive #4449, an ex-Southern Pacific "Daylight" engine, is used on special excursions from time to time. Its home is in Portland, Oregon. (*Steam engine photo by Steve Glischinski*)

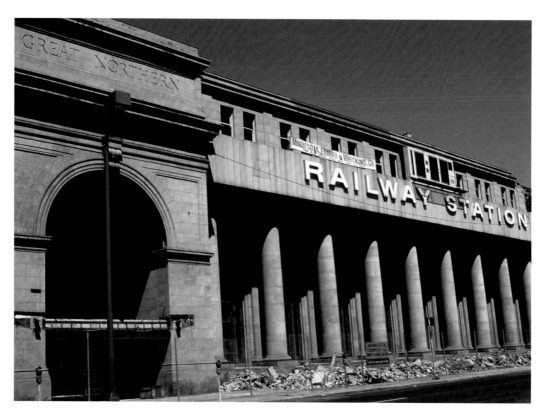

MINNEAPOLIS STATION: Built in 1913, the Minneapolis depot, located in the center of the city next to the Mississippi River, served Great Northern, Northern Pacific and Amtrak passengers until 1978. Today the site is occupied by the Federal Reserve Bank of Minneapolis.

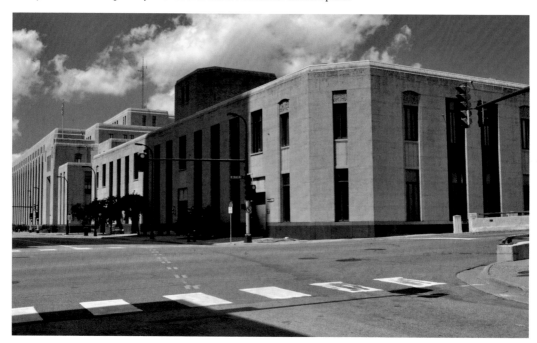

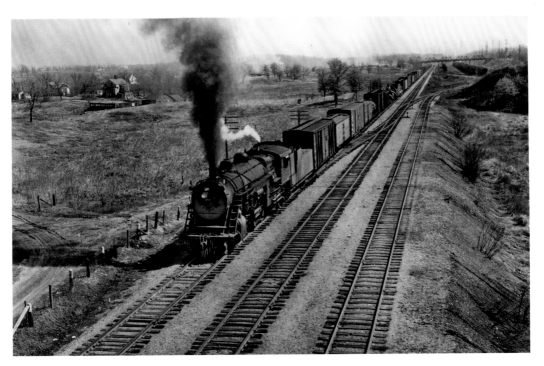

ST. LOUIS PARK: A steam-powered Great Northern freight train is seen in St. Louis Park, just west of Minneapolis, in this undated photo. The last steam operations on the Great Northern took place in August 1957. Later, one of the tracks shown here was removed; the roadbed is now a hiking trail. There are dozens of similar rails-to-trails all over the U.S. (*Steam train photo from Great Northern Railway Historical Society. Newer photo by Dan Kwarciany*)

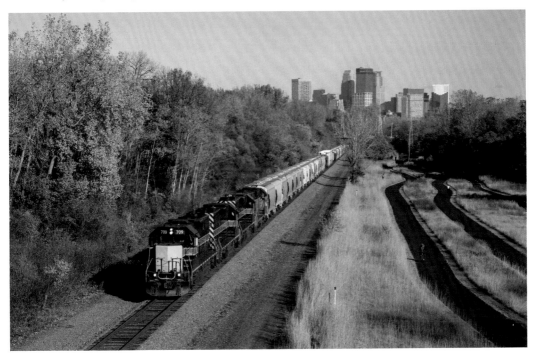

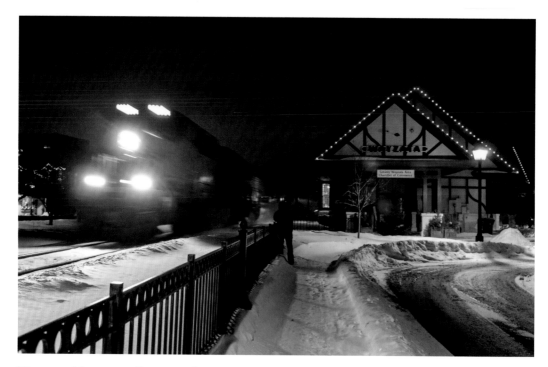

WAYZATA, MINNESOTA RAILROAD STATION: The depot in Wayzata, Minnesota—on the shore of Lake Minnetonka—has a story to tell! In 1883, the locals sued the railroad, complaining of the noise, smoke, and sparks that the trains were creating. Railroad president James J. Hill replied by closing the depot! Travelers thereafter had to take a carriage to the next town to catch the train! Years later, the town and Hill were reconciled, and this fine depot was built in downtown Wayzata. (*Shawn Christie photo*)

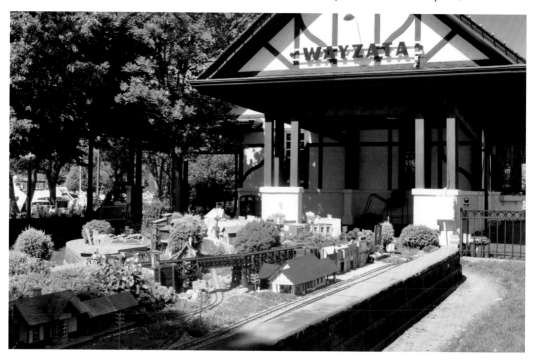

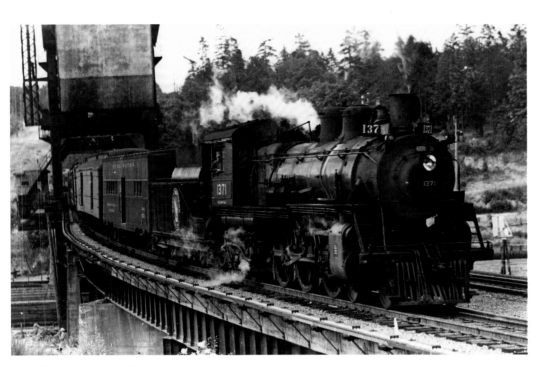

HIGH-STEPPING STEAM: The Pacific Locomotive, which made its appearance on U.S. railroads in the early twentieth century, was designed for high speed passenger service. It featured four guide wheels up front, six huge driving wheels, and another set of wheels in back to support the firebox. The Great Northern had four or five dozen Pacifics, divided into seven classes according to size. Engine 1358 is shown in service just north of Seattle. Sister engine 1355 has been restored for display at Siouxland Historical Railroad Association in Sioux City, Iowa. (*Photo by Larry Obermeyer. Action photo by James Turner*)

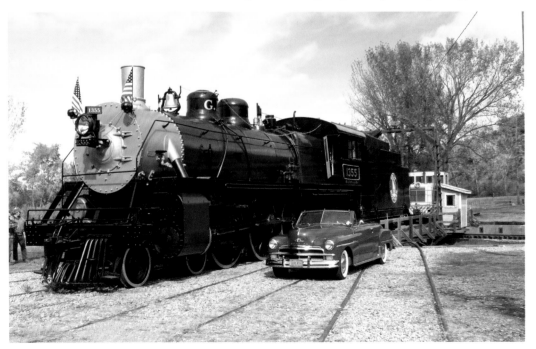

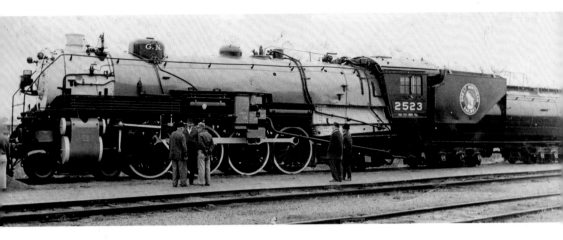

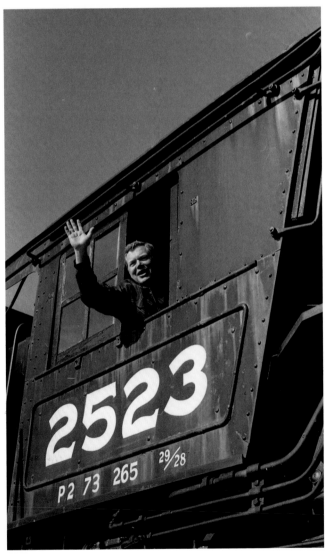

THE P-2 "MOUNTAIN" CLASS LOCOMOTIVE: Engine 2523 can be seen on display at the Kandiyohi County Historical Society in Willmar, Minnesota. One of twenty-eight in class P-2 purchased by the Great Northern, the P-2 was able to run from Seattle to St. Paul without major servicing. Dedication ceremony for 2523 took place in October 1965. (*Kandiyohi County Historical Society photo*)

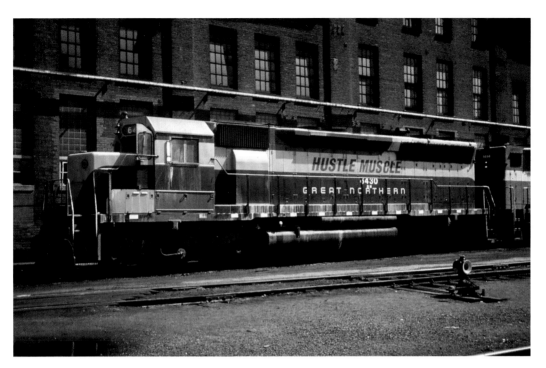

HUSTLE MUSCLE: In 1965, the Great Northern took delivery of the first SD45 diesel locomotive from Electromotive Division, General Motors Corporation. Nicknamed *Hustle Muscle*, the big diesel-electric developed 3600 horsepower and weighed 367,200 lbs. After twenty years of mainline service on the Great Northern and Burlington Northern, *Hustle Muscle* was retired and donated to the Great Northern Railway Historical Society. It can be seen at the Minnesota Transportation Museum in St. Paul. (*Night shot by Bob Ball*)

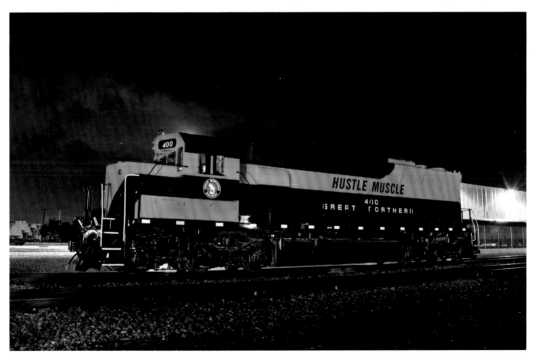

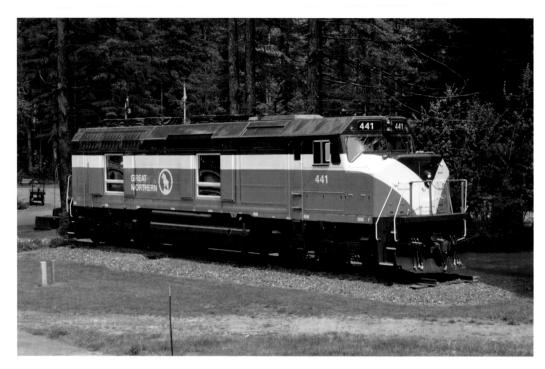

A Unique Wilderness "Cabin": A cousin to #400, F-45 engine #441, has been placed on a short panel of track at Essex, Montana. Like *Hustle Muscle*, the #441 was used in mainline freight service and as a helper engine in the mountains. In 2010, the engine's internals were removed and the shell was converted into a posh cabin for travelers looking for a unique place to stay. The combination blue-black-and-white was the last paint scheme used by the Great Northern and was referred to as "Big Sky" colors. (*Bob Oestreich photo*)

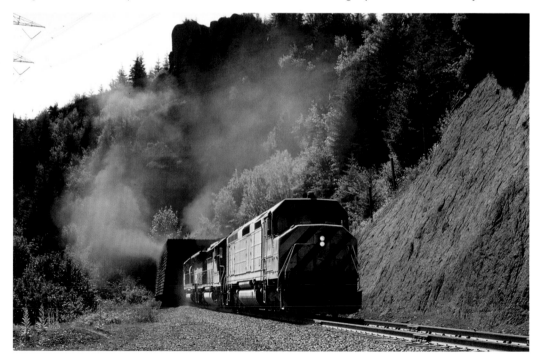

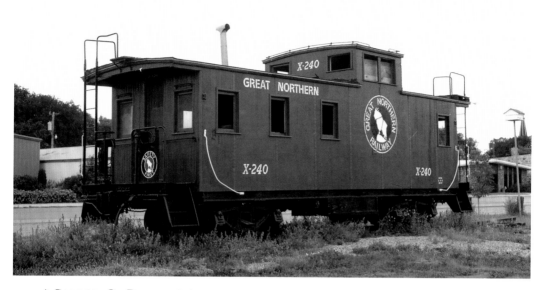

A CABOOSE ON DISPLAY: Cabooses carried the conductor and other crewmen whose duty was to observe the train and signal the engineer in case of mechanical trouble. Cabooses began disappearing from American railroads in the 1980's, their train-monitoring function replaced by electronic devices. After thirty-four years of service, GN caboose X-240 was retired and put on display in Buxton, North Dakota. The car was later given to the Great Northern Railway Historical Society and was moved to Waite Park, Minnesota, where it was lovingly restored to its original 1943 condition by local volunteers.

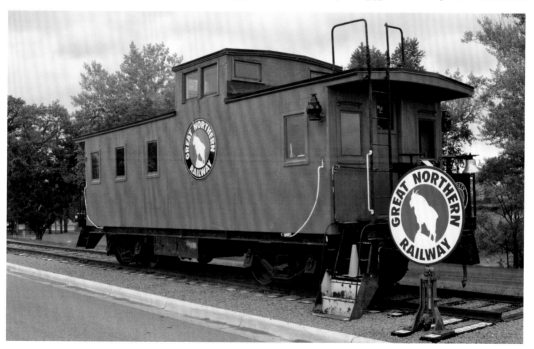

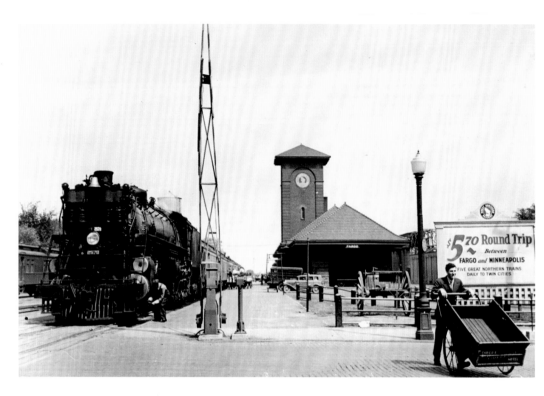

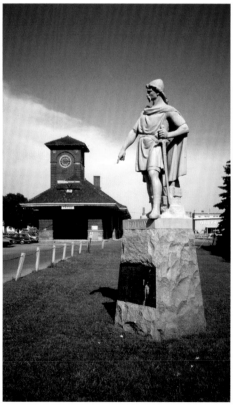

FARGO STATION: The Great Northern Depot in Fargo, North Dakota, was built in 1920. It served passengers for fifty years, and then was converted to an upscale restaurant. Later it became the home of the Great Northern Bicycle Company. Amtrak still stops at the depot on its daily eastbound and westbound trips. (*Library of Congress: Arthur Rothstein f.s.a.*) (*GNRHS*)

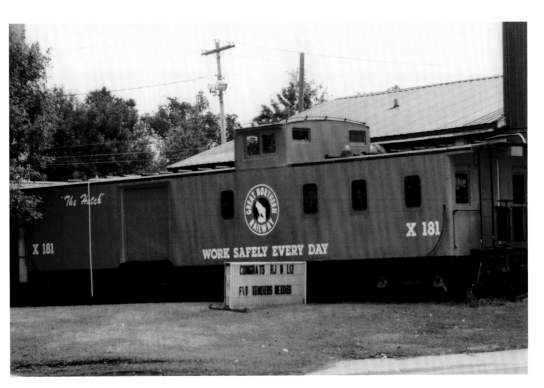

THE BIG CABOOSE: The "Hutch" caboose at Devils Lake, North Dakota, is now a wing of the *End of the Line Bar*. Before its retirement, the caboose carried crew members and freight on the Great Northern line from Minneapolis to Hutchinson, Minnesota.

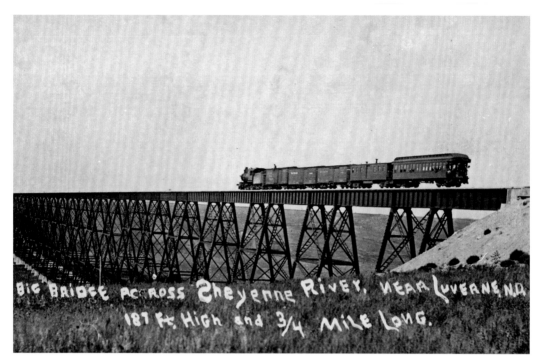

SHEYENNE RIVER BRIDGE: The great steel viaduct at Luverne, North Dakota, spanning the Sheyenne River is a major feature of the Surrey Cutoff, a GN mainline that runs diagonally across the state from Fargo to Minot. The bridge is a steel viaduct composed of box spans supported by towers. It has handled daily traffic since the Cutoff opened in 1912. The Luverne Viaduct is a reminder to the unwary that North Dakota is not particularly flat! Later photo dates to 1998.

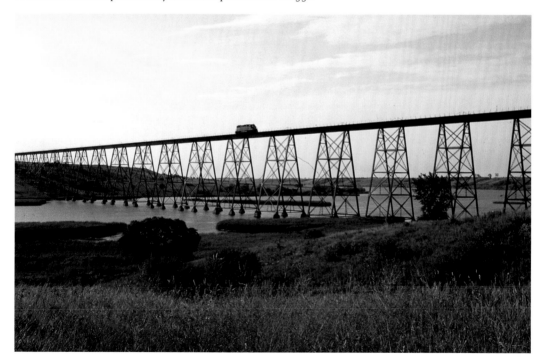

THE THOMPSON MONUMENT: In 1925, the Great Northern placed this marble monument near Verendrye, North Dakota, on the Surrey Cutoff. It honors David Thompson, who explored the Northwest in the early years of the nineteenth century. Thompson has been called the greatest land explorer that ever lived. The Thompson River in British Columbia is named for him, as well as the city of Thompson Falls, Montana. (*Minnesota Historical Society*)

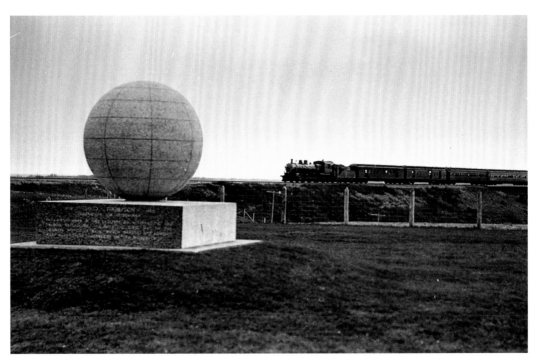

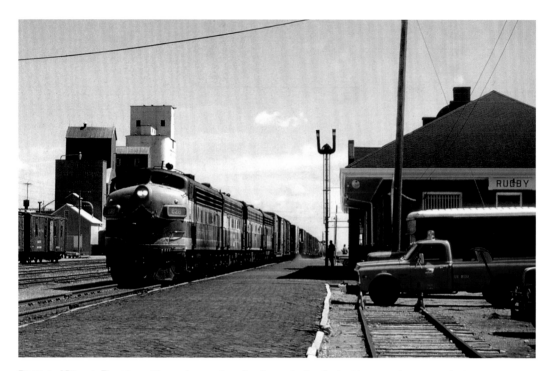

RUGBY, NORTH DAKOTA: The train passing the depot in Rugby in May 1972 has several of the last remaining F-units, each sporting the paint scheme of one of the railroads that merged in 1970 to form the Burling-ton Northern Railway. F-unit 400 was GN's first set of FT diesel locomotives. They arrived on the property in December 1943. The FT is given credit for the displacement of the steam locomotive on American mainlines. (*GNRHS photo; Rugby photo by Bill Hooper*)

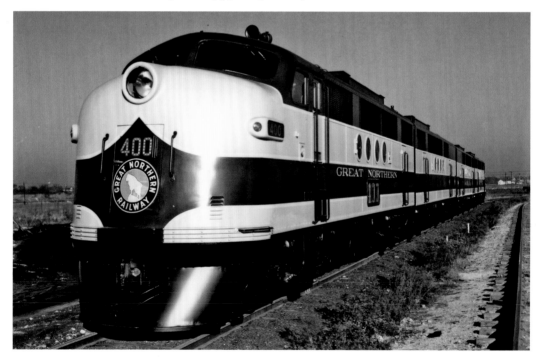

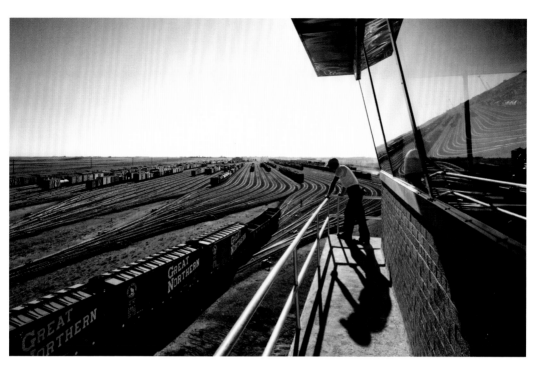

GAVIN YARD IN MINOT, NORTH DAKOTA: Minot's Gavin Yard, built by the Great Northern in 1956, was a major marshalling yard for shipments east from North Dakota to Duluth or to Minneapolis. The two mainlines split a few miles east of town. Sorting of cars was done by rolling them one-at-a-time over a small knoll or "hump". Switches activated by remote control directed each car onto a storage track with other cars having the same destination. (*GNRHS*) (*W. Pete Peterka color slide*)

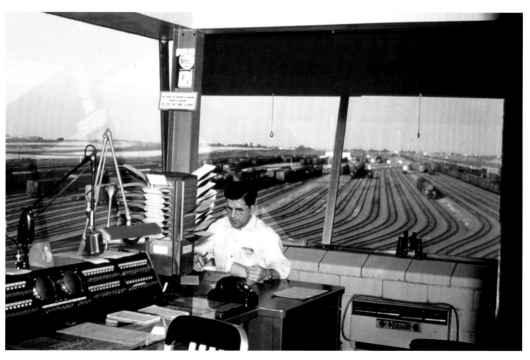

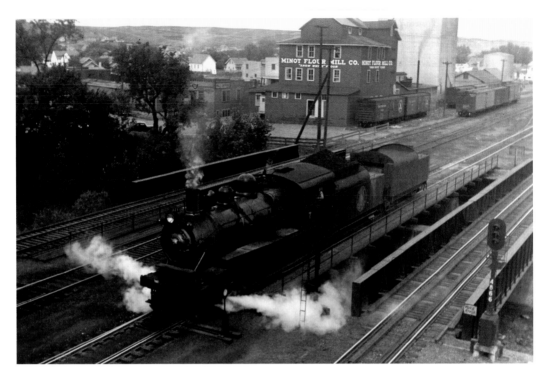

CROSSING THE BRIDGE INTO MINOT: In the years before Minot, North Dakota, got its official name, the place was known as "the second crossing of the Mouse River". The 1998 photo of the Amtrak *Empire Builder* on the Mouse River Bridge in Minot shows the contrast between modern power and the old twelve-wheeler "Mastodon" built in 1890. (*Casey Adams collection*)

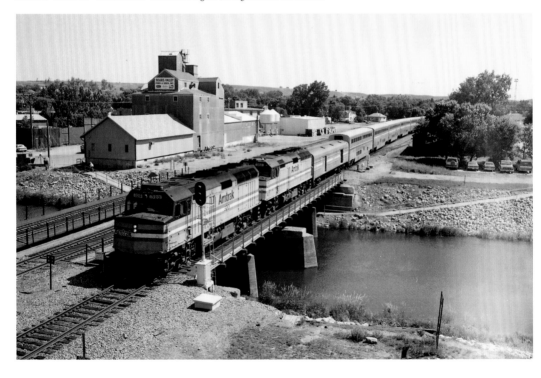

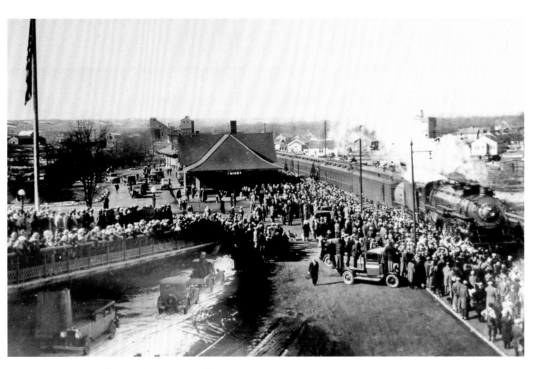

THE MINOT GREAT NORTHERN DEPOT: The depot in Minot is crowded with visitors in 1923 for some unremembered event—the flag is at half-mast. The depot was built in 1904; it was extensively rebuilt in 1963. The new "modern" design shows a stucco-covered, flat-roofed box. In 2012, the depot was completely restored to its original appearance. As this is written, Minot is in the center of a busy petroleum exploring area and is experiencing an economic boom.

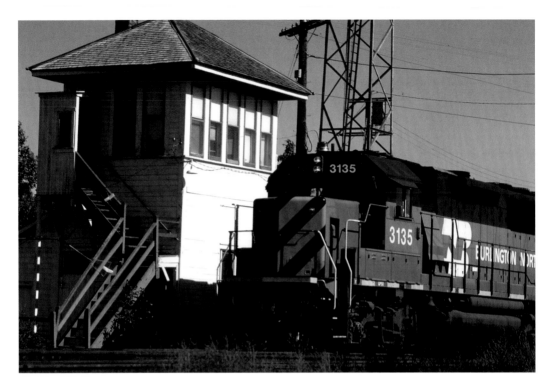

WHEN RAILROADS CROSS: The Soo Tower in Minot controlled the crossing of the Great Northern and the Soo Line in the years before train traffic was controlled by radio and by Centralized Traffic Control. Tower operators were on duty day and night to receive train information from the far-off dispatcher by railroad telegraph. The operator then set the signals to allow an approaching train to cross the "diamonds" without fear of colliding with another train. Extra instructions for engineers and conductors were written by the operator and were passed up by "hooping". The message was rolled up and tied with string. Train crew members grabbed the loop of string held in a wooden or metal hoop. (*Casey Adams*)

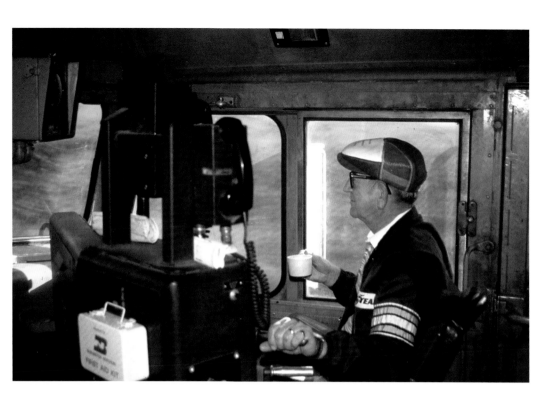

ENGINEER SMOKEY DAVIS: Neil "Smokey" Davis'
career as locomotive engineer spanned the late
steam and early diesel era. He is shown in 1981
driving Amtrak Train #7, *The Empire Builder*, on the
run from Minot to Williston, North Dakota. In
1998—and long since retired—Neil and his wife,
Leila, came downtown to see engine #261 arrive
in Minot with a BNSF "Employees Special".

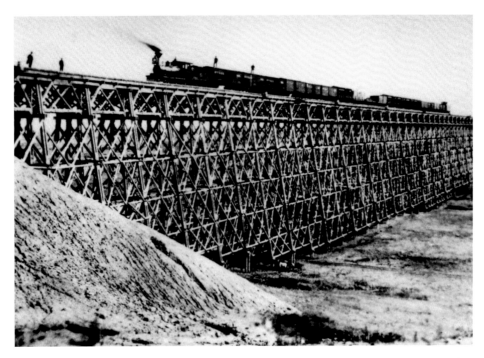

THE GASSMAN COULEE BRIDGE: The Gassman Bridge, located three miles west of Minot, is 1792 feet long and stands 117 feet at its highest point. The bridge was built by the Great Northern to replace an earlier wooden one destroyed in a windstorm in 1899. Fortunately, the new steel bridge was already under construction when the storm hit; the new bridge was completed soon after. (*GNRHS photo*)

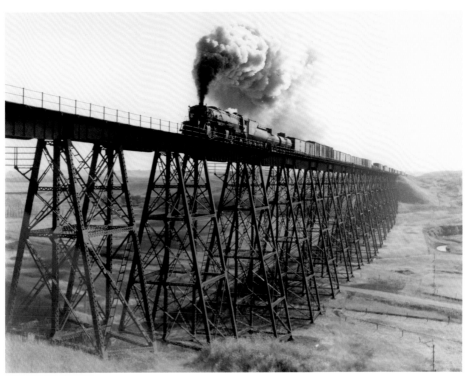

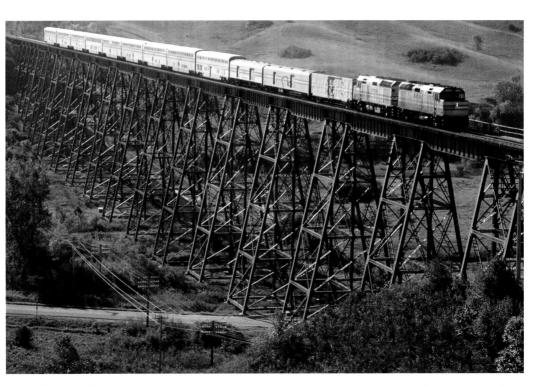

GASSMAN BRIDGE: The new steel bridge of 1899 was reinforced in 1923 to support heavier new engines. Now over a hundred years old, the Gassman Bridge is still in daily use by Amtrak and by Burlington Northern Santa Fe Railway.

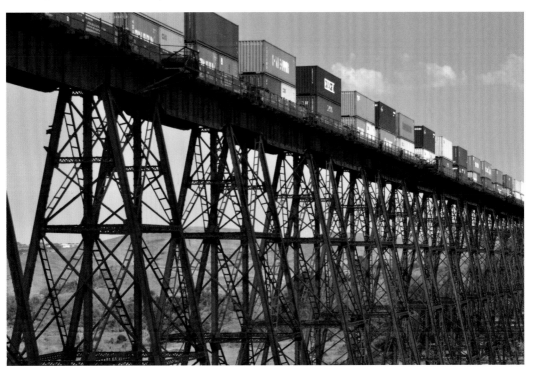

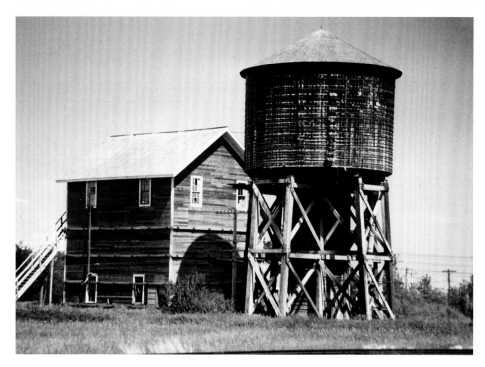

TANK AND WATER TREATMENT BUILDING: The old railroad water tank at Des Lacs, North Dakota, west of Minot, survived until 2013. It was one of literally thousands of similar structures across the U.S. that had served as trackside water storage and supply for passing steam engines. In many areas where the water supply was tainted with lime and other chemicals, facilities for softening the water were located in a small building next to the tank.

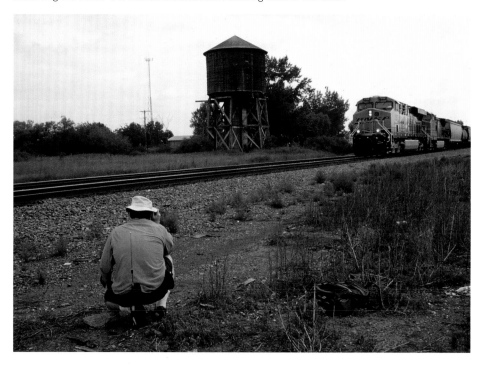

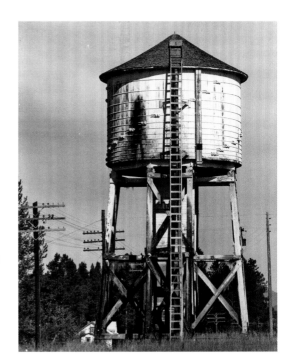

ONE LAST REMAINING WATER TANK:
The last remaining Great Northern wooden water tank from steam days is located at Park River, North Dakota, on a branch line. The tank is kept in good repair by the city of Park River. The earlier photo shows the Great Northern tank at Coram, Montana, when it was still in service. (*GNRHS*)

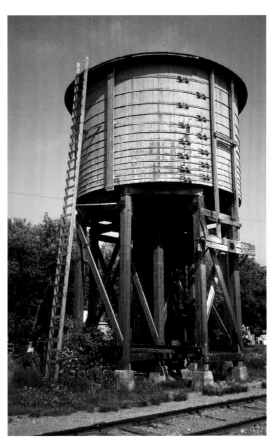

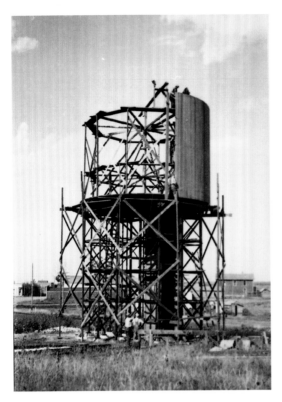

BUILDING A WOODEN WATER TANK:
Two dramatic photos from the collection of
the Historical Society of North Dakota show
the painstaking process of assembling a
wooden tank. The supporting base and the
bottom of the tank are already in place, and
extra beams support the narrow walkway
around the circumference. Scaffolding
is in place to give the workmen access
for placing the staves. After the roof has
been assembled, the tank will be wrapped
securely by metal bands to withstand the
pressure of 50,000 gallons of water. (*State
Historical Society of North Dakota*)

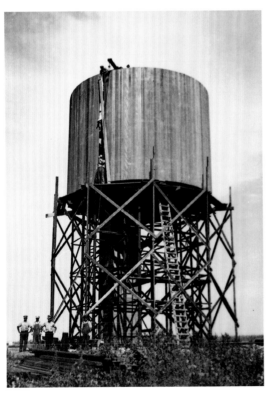

WILLISTON, NORTH DAKOTA: The town of Williston boasts a Great Northern steam locomotive, #3059, on display. The engine was built by Baldwin in 1911 and was a member of GN locomotive class O-1. The O- class marked a major improvement in steam engine design, with its oversized firebox and eight large driving wheels. (*Kandiohi County, Minnesota, Historical Society collection*)

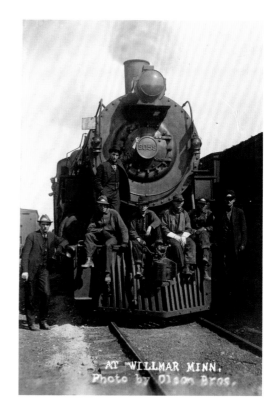

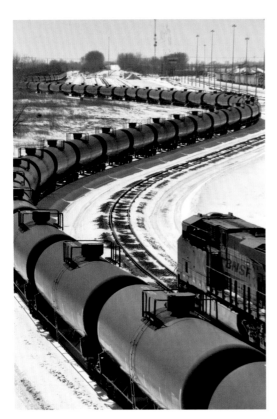

DRILLING FOR OIL: They've been looking for oil in North Dakota and Montana for a long time! The modern new exploration rigs seen along the "high line" of the BNSF are successors to the rigs that were prevalent in Tioga, North Dakota, and Cut Bank, Montana, in the 1930's! New technology allows oil to be extracted from areas formerly thought of as unproductive or unprofitable.

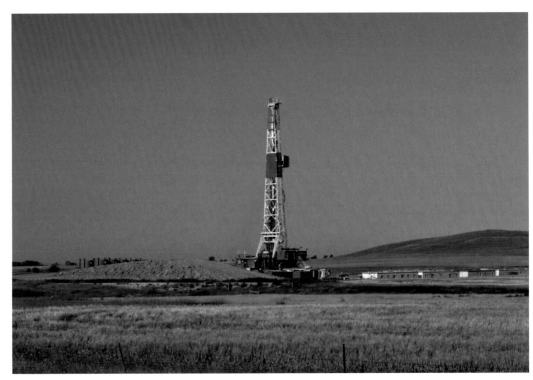

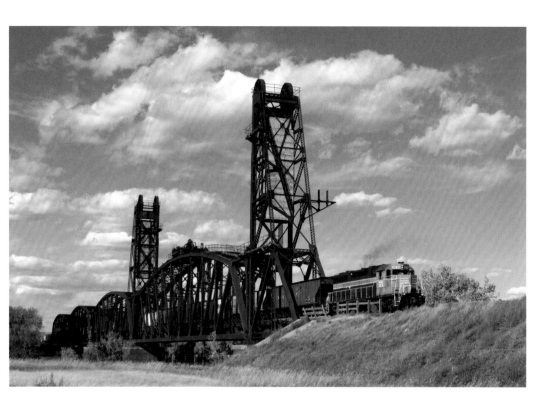

MISSOURI RIVER DRAWBRIDGE: The Snowden
Bridge carried a Great Northern branch line across
the Missouri River a few miles west of the North
Dakota-Montana line. Built in 1913, the 1000-foot
bridge gave rail access to the town of Fairview and
a connection with the Northern Pacific Railroad
in Sidney, Montana. The bridge cost nearly a
half million dollars to construct and featured a
central draw span, made necessary by the need
for steamboats to pass. The steam train is an
employees' special sponsored by the BNSF in 1998.
(*Modern photo of Yellowstone Valley freight by Stan Short*)

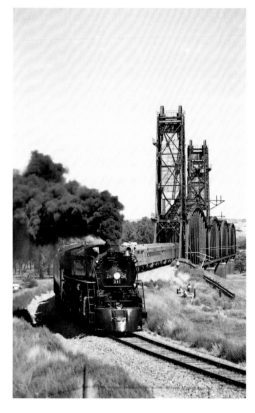

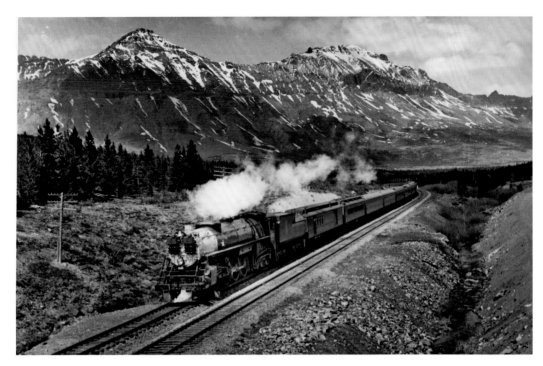

ENGINE ON DISPLAY: On the Great Northern, engine #2584 was one of the glamor engines, designed for high speed running with mainline passenger trains. The S-2 class featured eighty-inch driving wheels—the largest drivers on a Northern-type steam locomotive up to that time. The #2584 is on display at the depot in Havre—a daily stop on Amtrak. The most photographed engine in Montana! (*Warren McGee photo, GNRHS*)

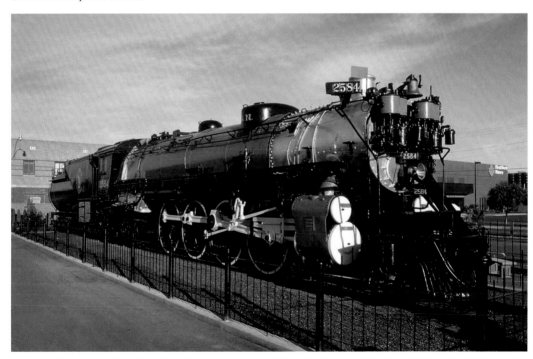

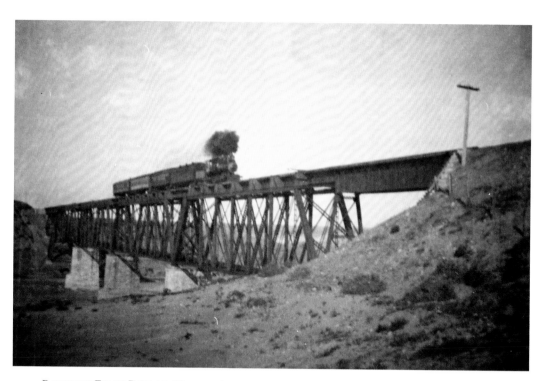

RAINBOW FALLS BRIDGE: The massive steel Rainbow Falls Bridge over the Missouri River is located on the line from Great Falls to Fort Benton. The track was formerly the Great Northern mainline. As this is written, the branch to Fort Benton serves only a local customer. The line north of Fort Benton has been taken up. (*Great Falls Library Archive*)

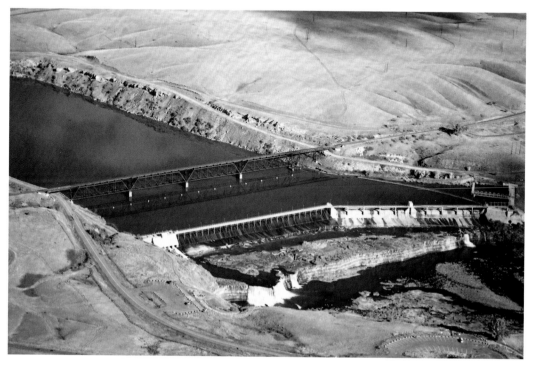

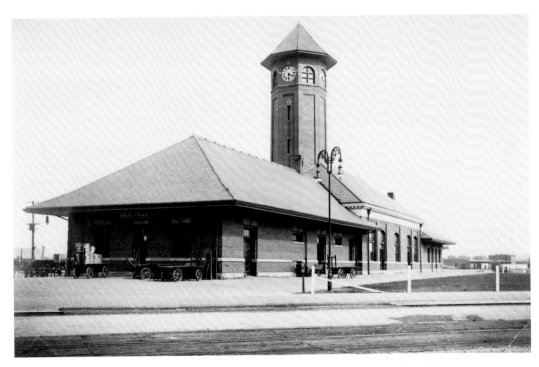

THE DEPOT FROM ABOVE: A unique view of the former Great Northern depot in Great Falls taken from the tower of the former Milwaukee Road depot. The track at the bottom of the photo is the line from Fort Benton; the upper track connects with Billings and Kansas City. The bridge across the Missouri is off to the right. The Great Northern depot is now the office of Energy West, the local gas company. (*Chuck Hatler photo*)

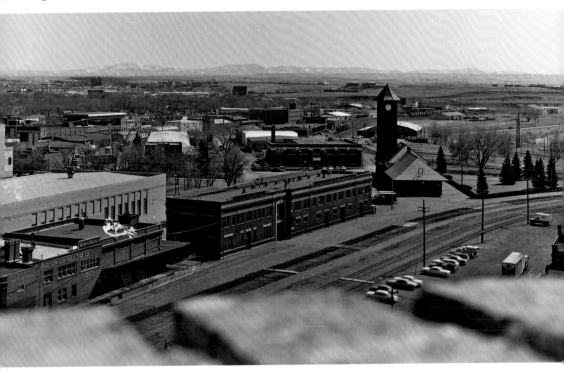

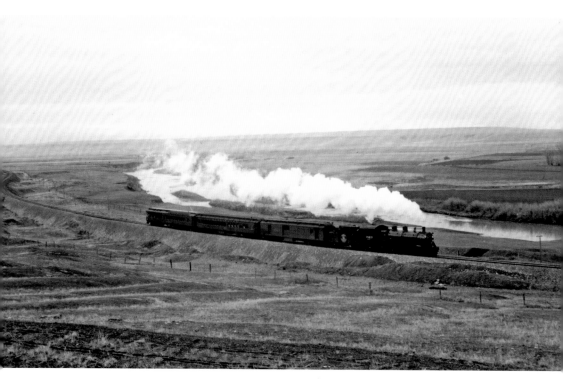

STEAM TRAIN NEAR GREAT FALLS: Train #43 is on the old Great Falls &Northern line to the Canadian border. (*April 24, 1941, Warren McGee photo*) Amtrak #8, the *Empire Builder*, is shown eastbound just out of Shelby in May 2013. Montana Big Sky Country at its finest!

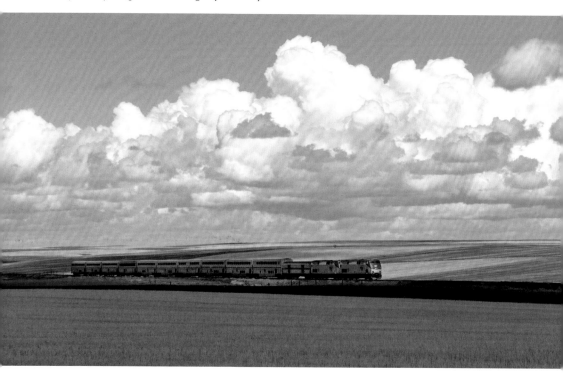

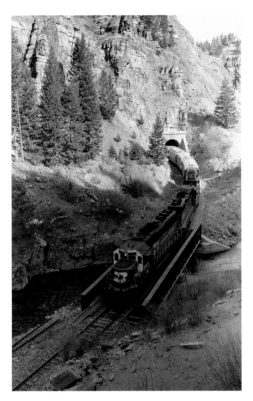

OUT OF THE TUNNEL: Tunnel Five is at the south entrance of Wolf Creek Canyon on the Great Northern line from Great Falls to Helena. The canyon was a major attraction on the GN with rock walls on both sides and the creek alongside the tracks. Before the coming of the rails, this area was passable only on horseback. The line was taken out of service in 1999, but tourists can still view the canyon on Interstate Highway 15. (*Steam photo courtesy GNRHS*)

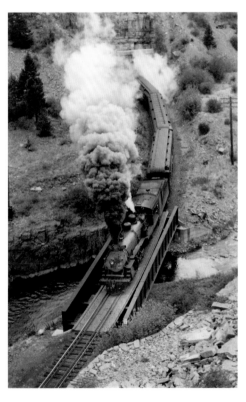

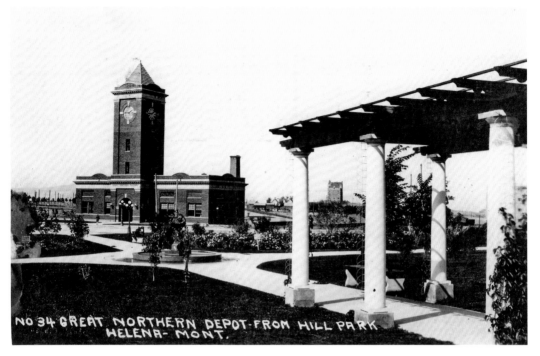

No 34 GREAT NORTHERN DEPOT-FROM HILL PARK HELENA- MONT.

THE PRIDE OF HELENA: The depot at Helena, the capital city of Montana, was located at the end of a mile-long spur that reached from the mainline into the center of town. The original building featured an impressive clock tower; it was damaged by an earthquake in 1935, and was never rebuilt. After passenger service was discontinued, the depot was removed and the site was occupied by the Federal Reserve Bank of Montana. (*GNRHS photo*)

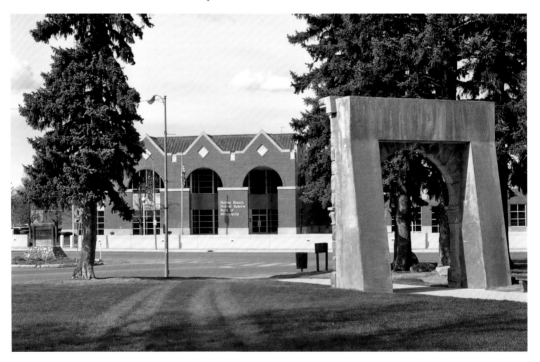

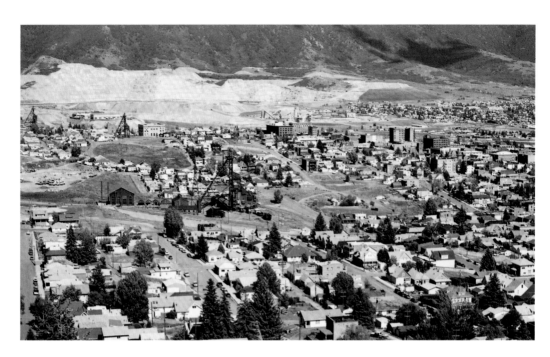

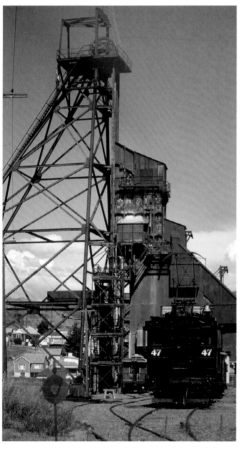

BUTTE, MONTANA: At its peak, Butte, Montana, was "the richest hill on earth". The first explorers found silver deposits in the area, but copper soon became the city's largest resource. The first shipments of ore from Butte were sent to far-off Colorado and New Jersey for refining. Later, smelters were built at Anaconda and Great Falls. The primary ore-hauler out of Butte—and coal supplier to the city—was the Great Northern. Eventually the underground mines and head-frame lifts were replaced by open pit mining. Massive trucks replaced mules, and diesel shovels move the earth. Hillside excavation replaced the huge Berkley Pit in 1982. The great hole remains an open sore on the community.

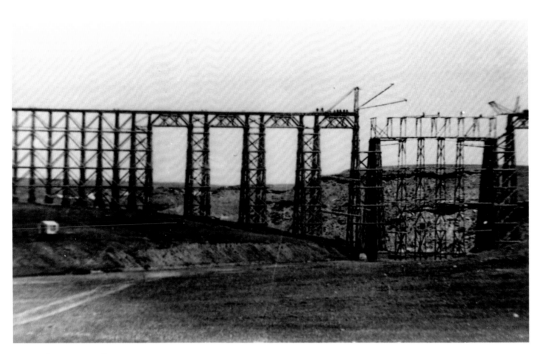

CUT BANK TRESTLE: On the Great Northern mainline to Seattle, the bridge over Cut Bank Creek is a real jaw-dropper! It was built in 1900 to replace a wooden trestle on the same site. Today it carries mainline freight traffic and Amtrak's *Empire Builder* one hundred feet above the creek bed. (*GNRHS photo*)

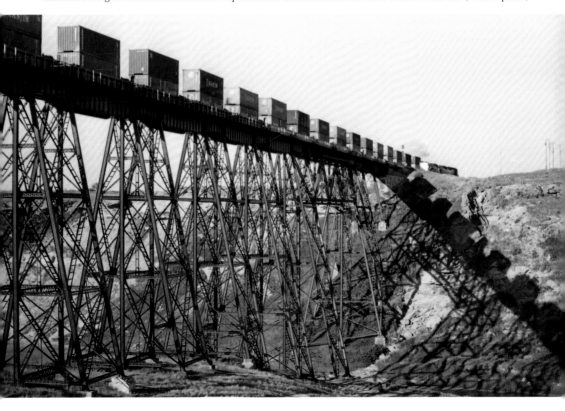

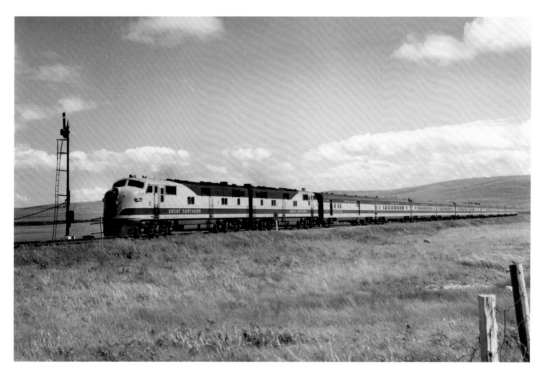

1947 EMPIRE BUILDER WESTBOUND: The railroads celebrated the end of the Second World War by ordering shiny new passenger equipment. "Streamliner" was the term to describe the new colorful coaches, diners and sleeping cars that made up Great Northern and other passenger trains in the late 1940's. (*Rail Photo Service photograph*)

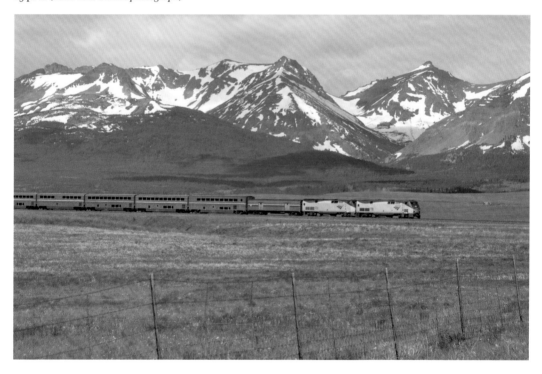

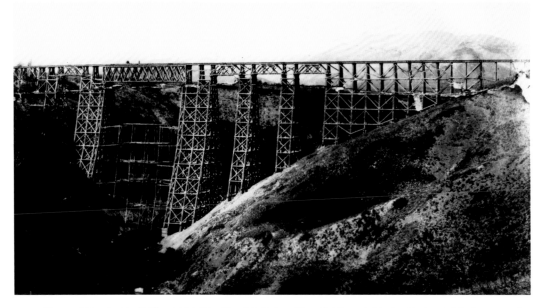

GREAT NORTHERN'S TALLEST: The Two Medicine River Bridge at Glacier Park—visible from nearby U.S. Highway Two and probably the most photographed bridge in the state of Montana—was the Great Northern's tallest—217 ft. above the water and 1040 ft. long. The original wooden trestle on this site was somewhat unsteady in its last years; it swayed. Train traffic had to be embargoed when the wind was blowing particularly hard. The installation of guy wires was a temporary remedy until the new bridge was built in 1903. (*GNRHS photo*)

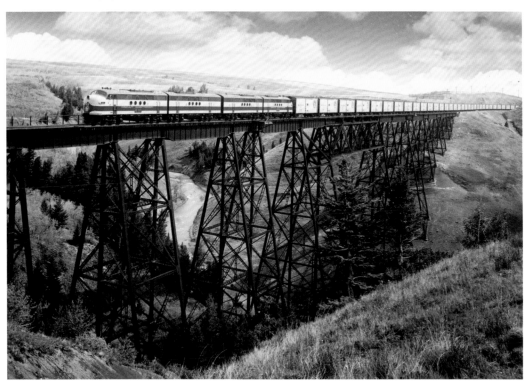

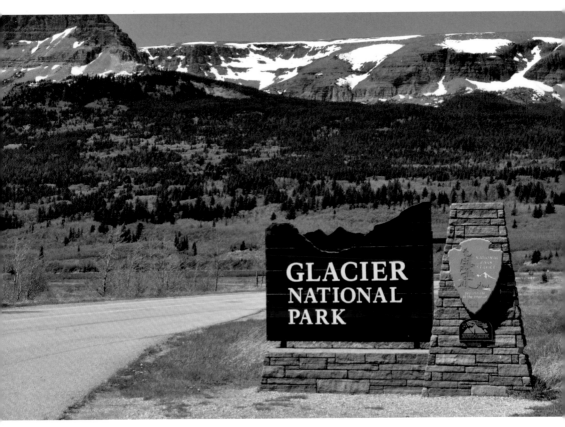

GLACIER NATIONAL PARK: Preserving a million acres of mountain ridges along the Continental Divide in western Montana, Glacier National Park attracts thousands of visitors annually. The Great Northern Railway and its new president, Louis W. Hill, were major influences in the founding of the park in 1910 and urging wealthy tourists to "see America first!" The hope was that they would come to Glacier Park by train. Today, many still arrive on Amtrak's *Empire Builder*. The train is sold out in summer months!

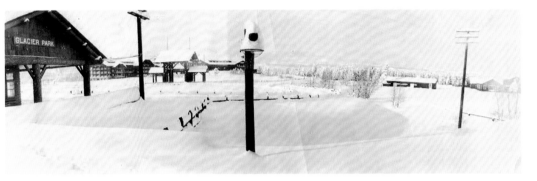

THE GLACIER PARK LODGE: Built in 1913 and located within walking distance of the depot, the lodge features a roof held up by massive first-growth tree trunks brought in by rail from the West Coast. The concept had been inspired by the Forestry Building at the 1905 Lewis and Clark Expo in Portland, Oregon. The snow scene dates to 1926. (*Scott Tanner collection*)

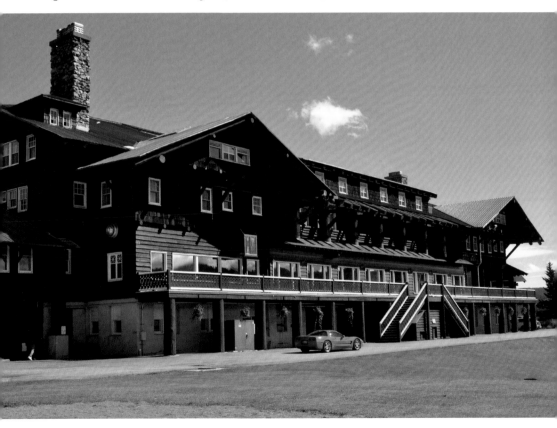

THE TRAIN STATION AT GLACIER PARK: The depot at Glacier Park likewise dates to 1913 and is still in daily use by Amtrak during the tourist season. (*Tanner collection*)

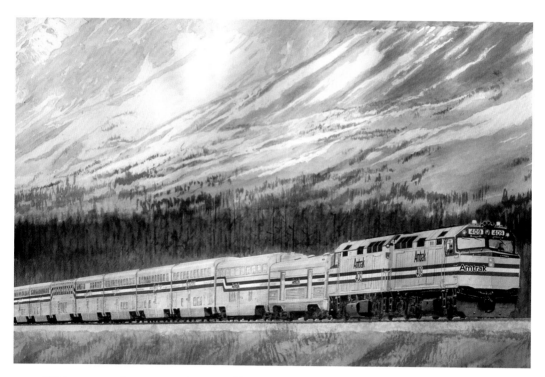

CONTINENTAL DIVIDE AND AMTRAK #8: The 1989 Amtrak calendar featured a Gil Reid oil painting of the Amtrak *Empire Builder* rolling down from the Continental Divide east of Marias Pass at a place called "False Summit". Five years later, a color slide of the same subject at the same spot featured a great coincidence! The leading engine on the train was the same, number 409! (*Used with permission*)

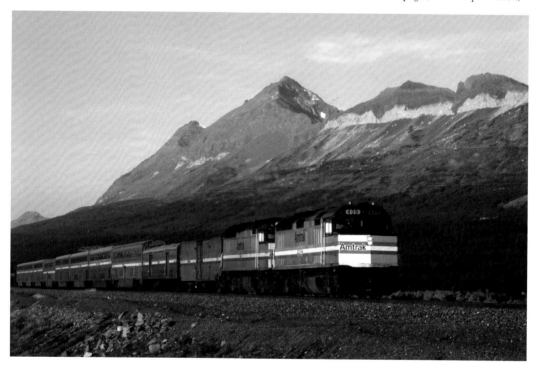

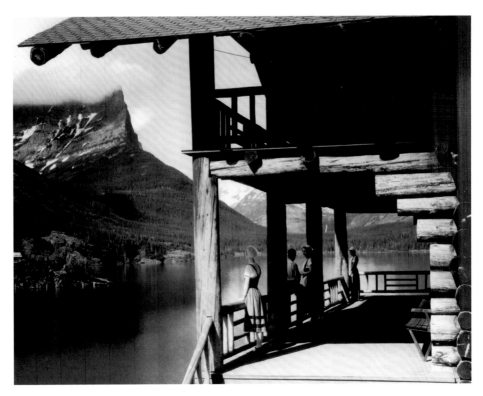

THE GLACIER PARK CHALETS: In Glacier Park's first years, the railroad built a series of lodges and dormitories throughout the park that allowed early visitors to trek through the wilderness for several days with overnight lodging along the way. The magnificent *Going-To-The-Sun Chalet*, located on the shore of Lake St. Mary's, could be reached by horseback or by boat. Today, the site of the chalet can be visited on *Going-to-the-Sun Road*, but the buildings were removed in 1947. (*National Park Service photo*)

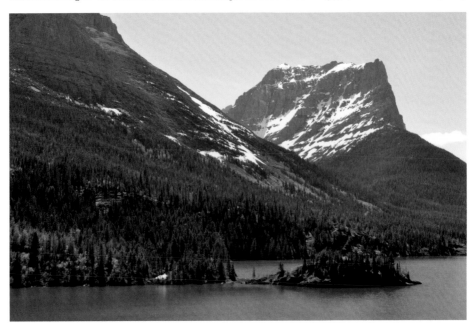

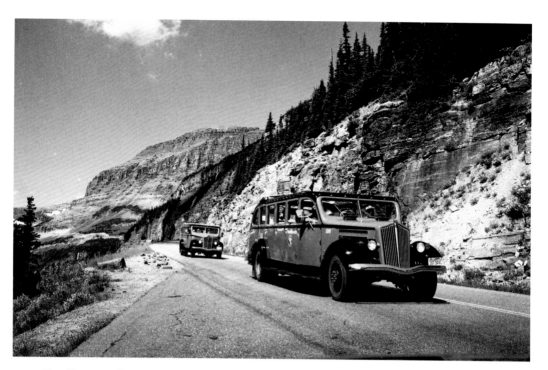

THE "JAMMERS": The first buses for touring the park, manufactured by the White Motor Company, were put into service in 1915. Twenty years later, a fleet of improved buses was built with larger motors and fold-back roofs that allowed riders to look up as well as out. They were ideal for seeing the peaks along *Going-To-The-Sun Road*. The buses had standard transmissions that required drivers to downshift on the hill sections. The shifting of gears led to the buses being nicknamed "jammers". (*National Park Service photo*)

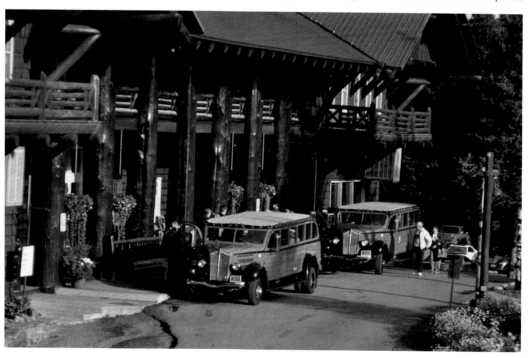

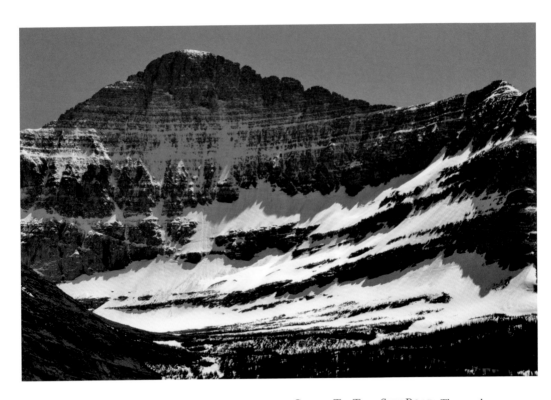

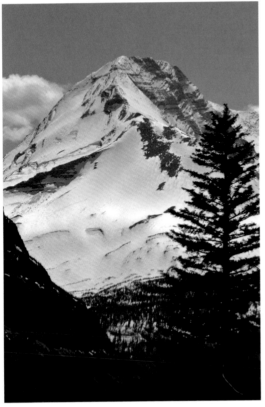

GOING-TO-THE-SUN ROAD: The road over Logan Pass in Glacier Park was named *Going to the Sun Road*. Originally built without guard rails, the road crossed the Continental Divide from Lake McDonald on the west side of the Divide to St. Mary's Lake on the east side. The road is often closed by heavy snow in winter and even in late spring months.

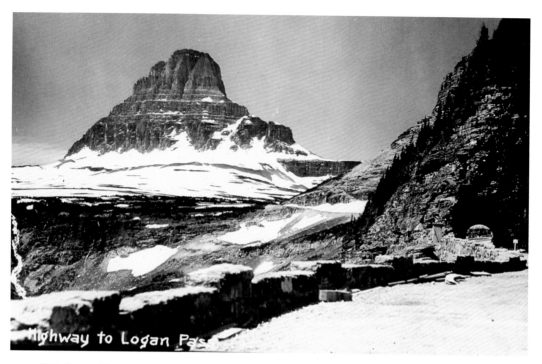

Highway to Logan Pass

THE QUICK TOUR: From the beginning, there were always Glacier Park visitors who did not want to spend a whole week in the wilderness. *Going-to-the-Sun Road* allowed visitors to eat breakfast at East Glacier lodge, visit Trick Falls on Two Medicine River, photograph the goats on 6,646 ft. Logan Pass, stop for dinner at the Lake McDonald Hotel, and sleep in the Belton Chalet at West Glacier—all in one day! *Going-To-The-Sun Road* was a federal project and was finished in 1933. By the year 2015, 4700 cars a day were using the road.

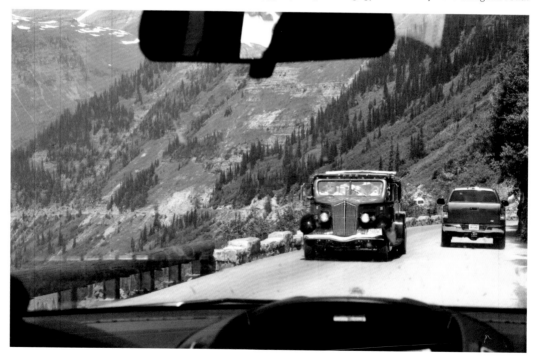

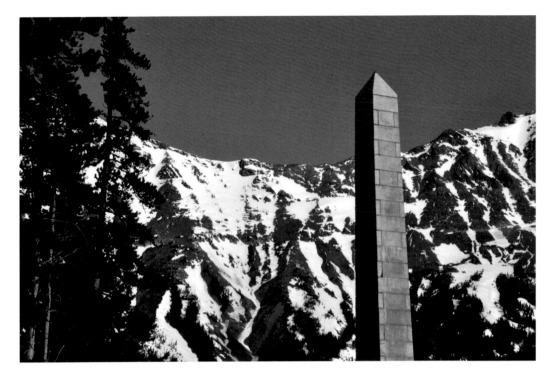

FINDING MARIAS PASS: Marias Pass was explored in 1889 by John Frank Stevens, one of the great locating engineers of the era. Stevens reached the summit in early December 1889. Caught by darkness before he could return to his base, he kept himself from freezing by tramping all night in the snow until the light of dawn allowed him to retrace his steps down the mountain.

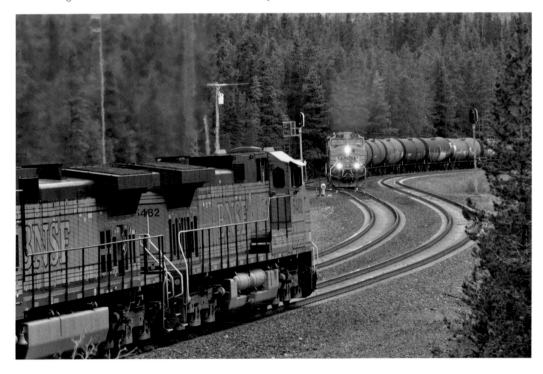

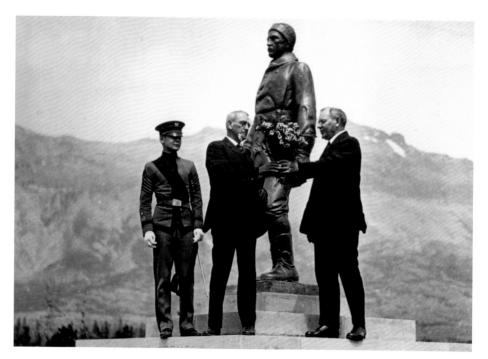

MARIAS PASS STATUE: The Great Northern placed a statue of John F. Stevens on Marias Pass in 1925. Present for the dedication ceremony, among others, were GN president, Ralph Budd, the Great Northern orchestra, noted Montana artist Charley Russell, Mr. Stevens and grandson John F. Stevens III, a student cadet at Shattuck Military School in Minnesota. Originally located north of the railroad tracks, the monument was moved to a nearby roadside rest area in 1986. Posing with the Stevens statue are GN historian Bob Kelly and author Gary Krist.

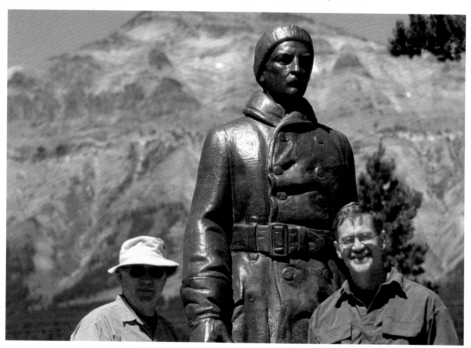

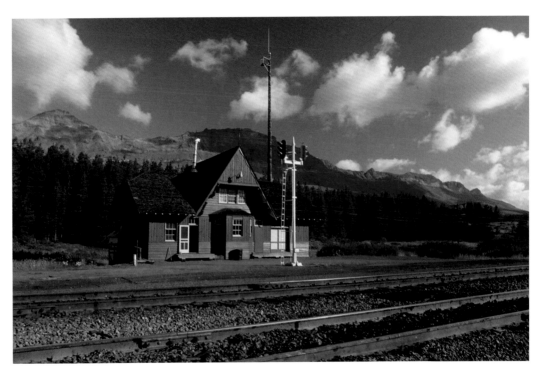

SUMMIT DEPOT: The Great Northern depot at the summit of Marias Pass, with its Swiss chalet look, served until the early eighties, when it was sold to a private owner. The building was moved to a site several hundred yards west of the summit where it became a restaurant. Today, visitors can sit and watch the trains through oversized windows—or outside on the rear deck!

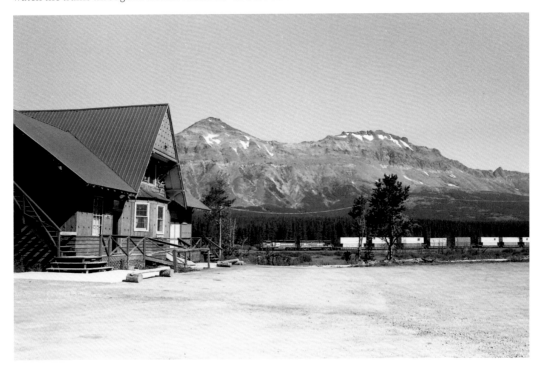

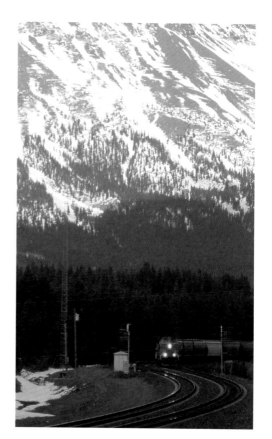

MARIAS PASS CROSSOVERS: Just west of Marias Pass, the rails have turned away from the Continental Divide to follow Bear Creek down to the Flathead River. Behind the train is 8800 ft. Little Dog Mountain. Just out of view at the right is U.S. Highway Two, which has provided access to this spot for generations of photographers. (*GNRHS*)

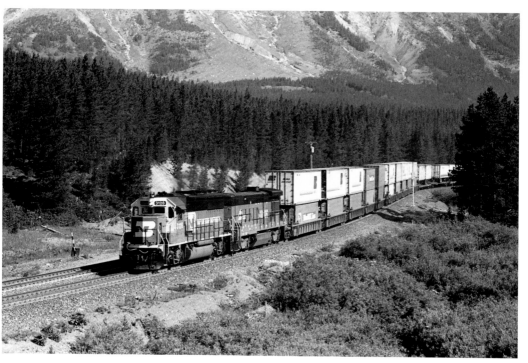

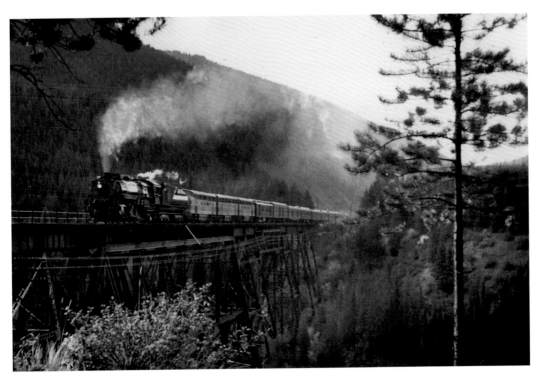

JAVA BRIDGE: At Java, the rails cross the Middle Fork of the Flathead River on a massive steel bridge. The original 1892 bridge was made of wood. The steel bridge dates to 1904; it underwent major strengthening in 1956. (*GNRHS*)

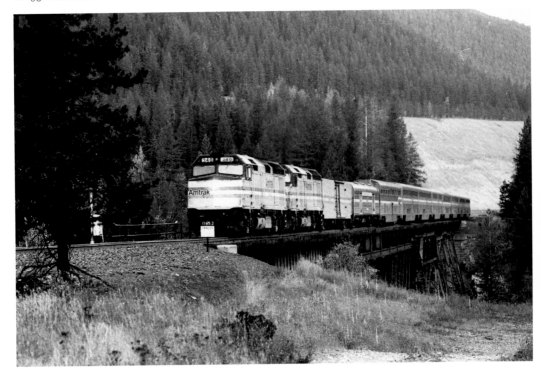

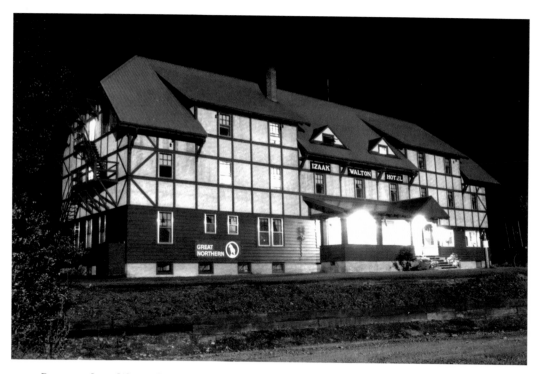

POPULAR *IZAAK WALTON INN:* For rail enthusiasts, U.S. 2 is the favored route over the mountains. The road follows the tracks of the Great Northern the entire way as they curve around the southern border of Glacier National Park. At Essex, west of Marias Pass, the *Izaak Walton Inn,* originally built for track workers and train crews, has been converted into a classy but rustic hotel for skiers, hikers, fishermen and train watchers.

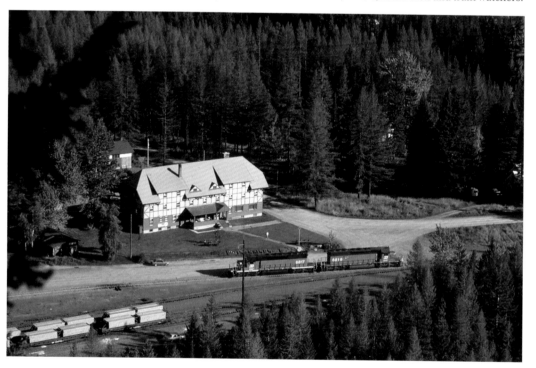

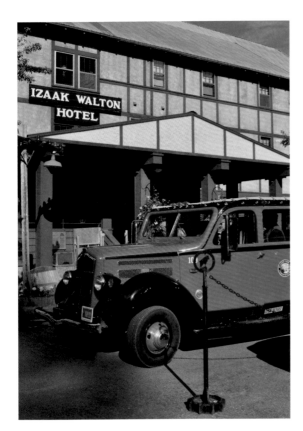

IZAAK WALTON INN: The *Izaak Walton* dates to 1939, but has been modernized several times. It now features plumbing in every room, a first-class restaurant, a basement game room / tavern, and an open porch for outside dining.

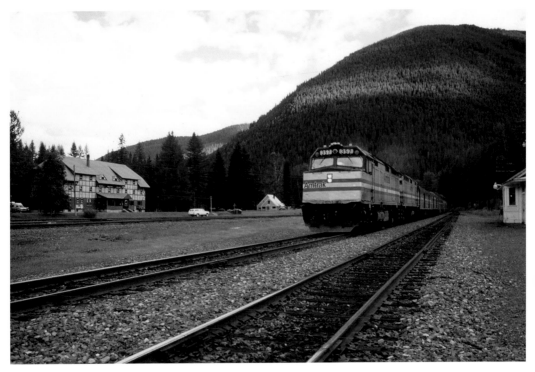

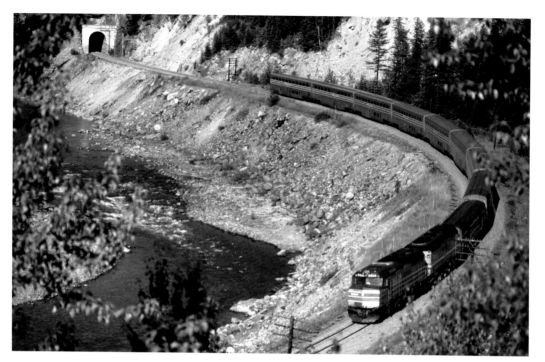

CURVE AT TUNNEL 4.0: Just east of the station at Belton, Montana (the west entrance to Glacier Park) is this curve at Tunnel 4.0. Ironically, the diesel photo of Amtrak's Empire Builder is the older of the two; it was taken in 1980, the year that Amtrak introduced their new double-deck passenger equipment. The steam engine photo was taken in 2009 as Southern Pacific Daylight #4449 was returning from a visit to Owosso, Michigan. (*4449 photo by Justin Franz*)

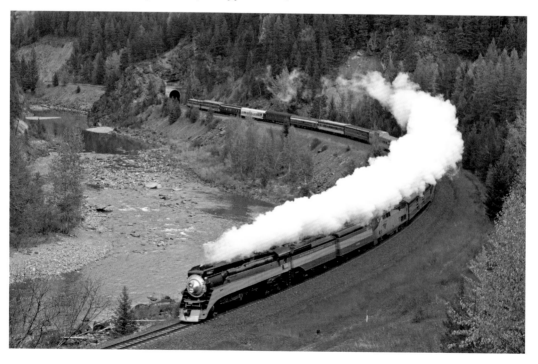

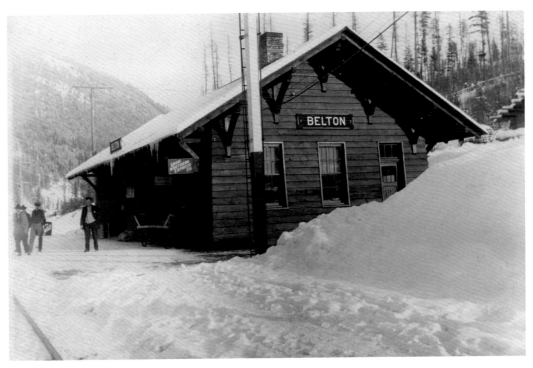

THE DEPOT AT BELTON: The daily Empire Builder stops at East Glacier, at Essex, and at Belton, on the parks' western boundary. Belton was the original destination for visitors who came by train. From the Belton chalet, across from the depot, it was a short ride to the lake, to Lake McDonald Hotel by steamer and the entrance to the park. (*GNRHS photo*)

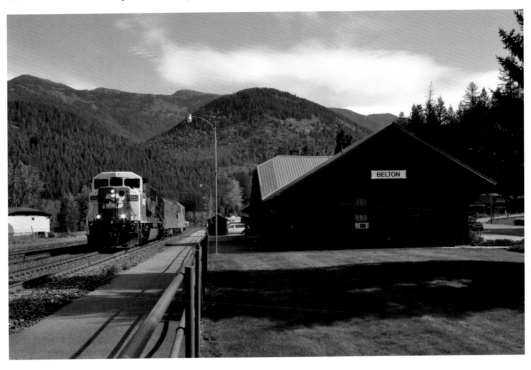

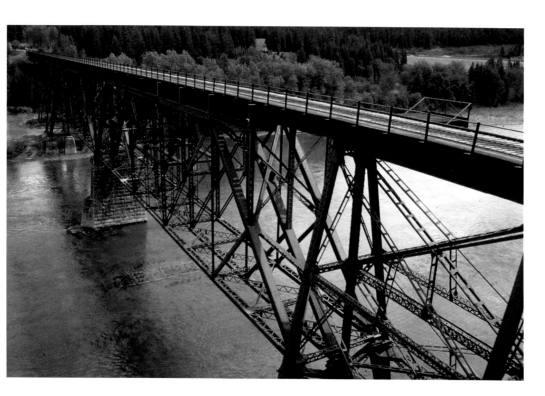

CORAM BRIDGE: At the west end of the park, the mainline crosses the Flathead River on a spectacular bridge built by the Burlington Northern in 1986. The "new" bridge replaced a steel bridge built by the Great Northern in 1900. Visible below through the clear mountain water are the footings of the original wooden bridge that dated to 1892.

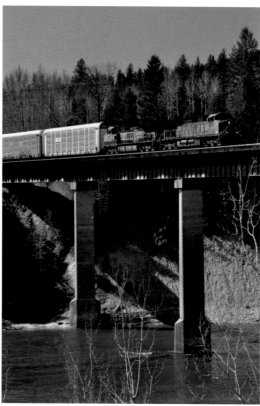

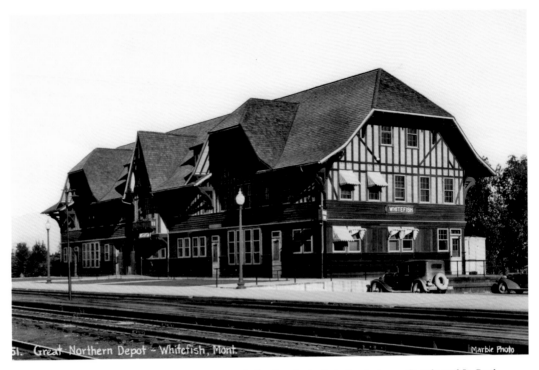

51. Great Northern Depot - Whitefish, Mont. Marble Photo

WHITEFISH STATION: Built in 1928, Whitefish is the busiest Amtrak station between Seattle and St. Paul. The depot serves tourists and especially skiers arriving on the daily *Empire Builder*. Its Tutor Revival styling is unique among the major Great Northern stations. It boasts a small visitors' center and museum. In 1990, the railroad sold the structure to the local Stumptown Historical Society. (*GNRHS photo*)

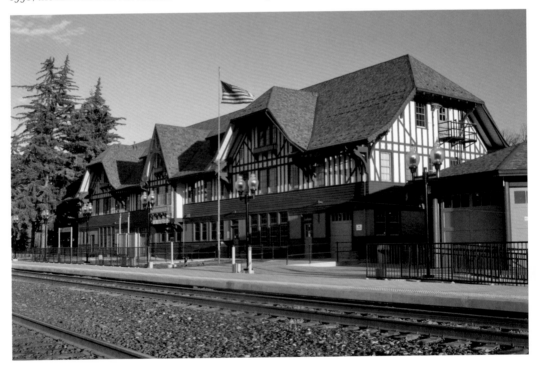

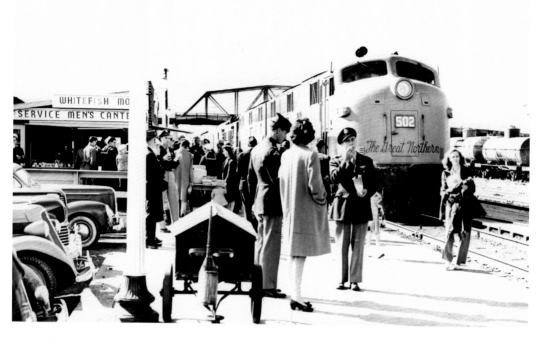

WHITEFISH CANTEEN: Whitefish, Montana, was the site of one of the famous trackside "canteens" set up by locals during World War II to welcome servicemen riding the trains to training camps or to ports of embarkation. The young women supplied donuts, coffee, and a friendly welcome that many soldiers long remembered! (*GNRHS*)

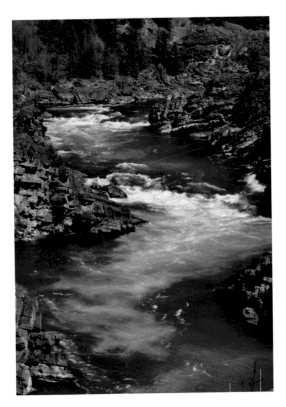

KOOTENAI FALLS: From the earliest days, remote Kootenai Canyon has been the least settled and the least developed area along the entire Great Northern mainline. U.S. 2 follows the river and the tracks for miles. Main attractions are Kootenai Falls, west of Libby, and Lake Koocanusa which forms behind Libby Dam.

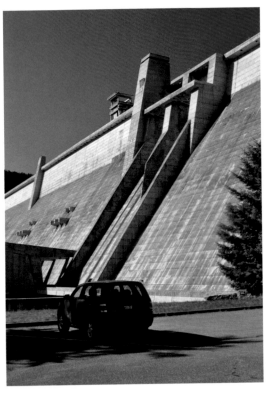

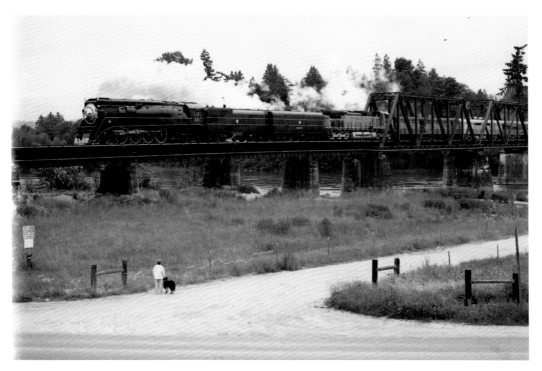

STEAM TRAINS THEN AND NOW: In the late 1940's, Warren McGee was out taking pictures of the Great Northern in northwest Montana. The eastbound refrigerator train was rolling just east of Vista Tunnel behind one of the mighty o-8 class Mikados. Fifty years later, ex-Southern Pacific #4449 is crossing the Nooksack River in Ferndale, Washington, with an employees' special.

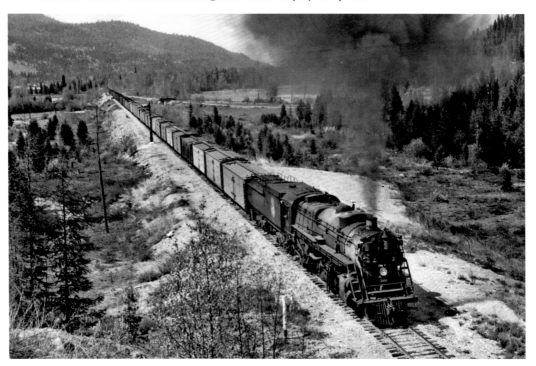

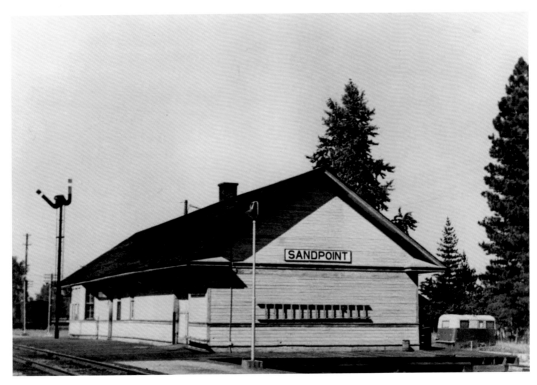

A MODERN DEPOT: A number of Great Northern depots were rebuilt after the war with modern features: new interior layout, modern bay window, new roof, and large, individual cut-out lettering for the station name. (*color photo: GNRHS; black-and-white from the Harold Hall collection*).

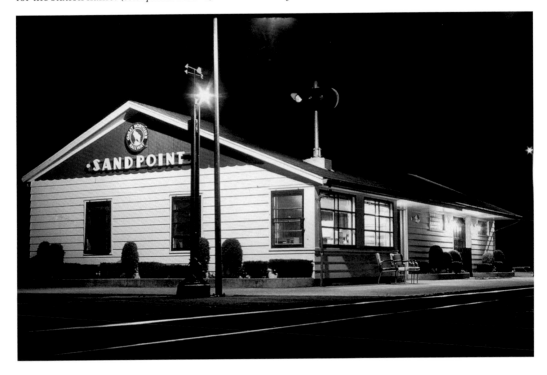

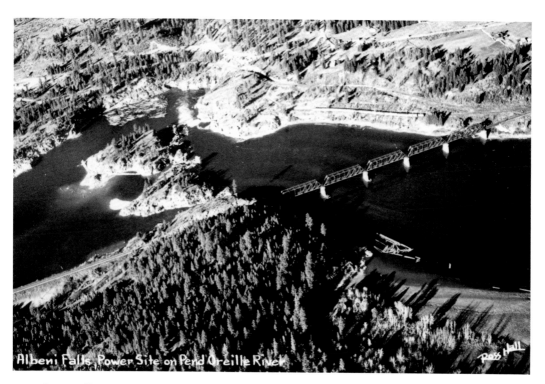

Albeni Falls, Power Site on Pend Oreille River

Ross Hall

ALBENI FALLS: Albeni Falls was drowned with the building 1951-55 of the dam on the Pend O'Reille River. The railroad crosses the river just upstream from the dam. The tracks are still in daily use, but only as an industry lead; the BNSF mainline takes another route from here into Spokane, Washington.

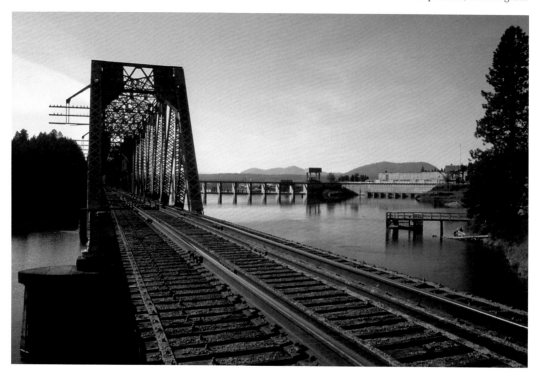

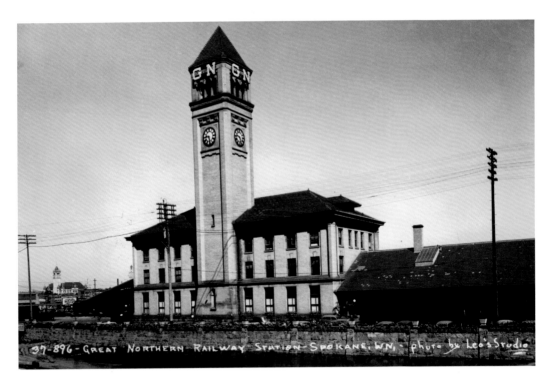

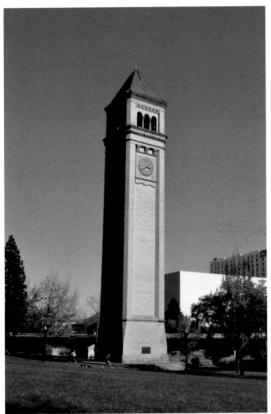

DEPOT AT SPOKANE: The Great Northern arrived in Spokane in 1892. Here the Spokane River tumbles over a series of falls. The tower of the Great Northern depot built on Havermale Island in downtown Spokane survives today in a modern park setting. The depot itself was razed in 1974 to make way for the Spokane World's Fair, *Expo '74*. (*GNRHS*)

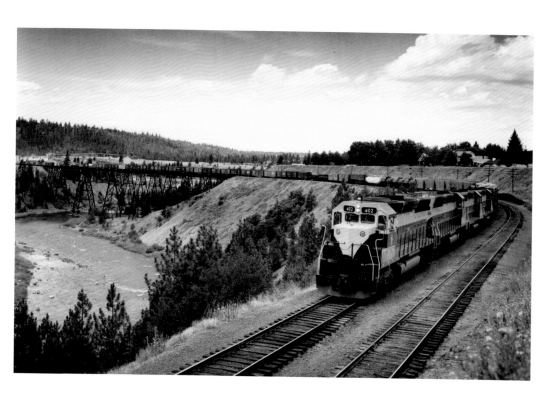

THE NEW BRIDGE: The Great Northern steel viaduct over Latah Creek, west of downtown Spokane, was removed in 1972 as part of the city's modernizing program. A spectacular new 3800-foot viaduct was built to carry rail traffic from Portland and Seattle on the Burlington Northern Railroad. (*GNRHS*)

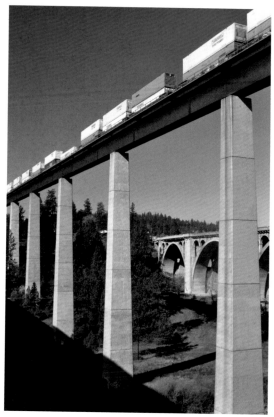

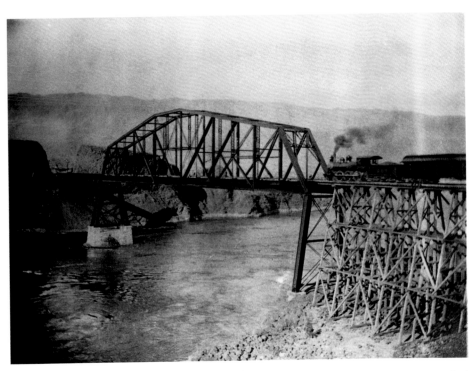

COLUMBIA RIVER: At Rock Island, the Great Northern crossed the Columbia River on a 404-foot steel truss bridge. Still in use today, the bridge has been strengthened by the addition of another truss wrapped around the earlier one. Below, the mighty Columbia flows to the sea, cold, swift and deep. There are no boaters, skiers or swimmers to be seen on this dangerous stretch of river. (*GNRHS*)

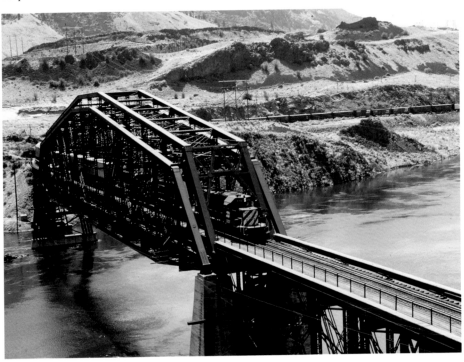

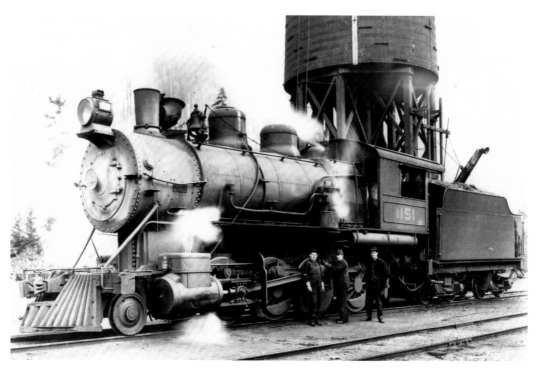

HUNDRED-YEAR-OLD STEAM ENGINE: On display in Wenatchee, Washington, is old engine #1147, built by Rogers Locomotive Works in 1904. With a tractive effort of 32,000 lbs. the engine and others in its class, were considered mainline power in their day, especially in the Cascades, where the ruling grade was a steep two percent.

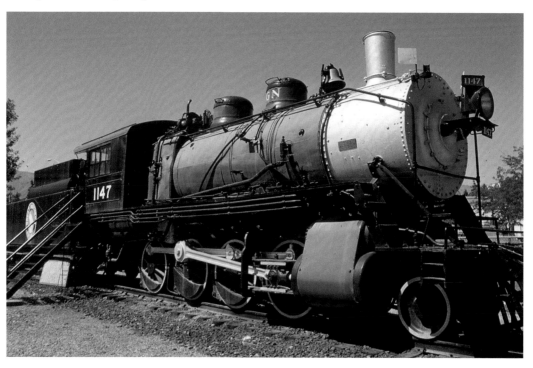

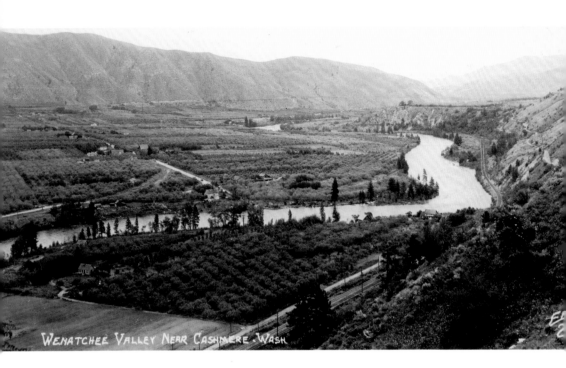

WENATCHEE VALLEY NEAR CASHMERE, WASH.

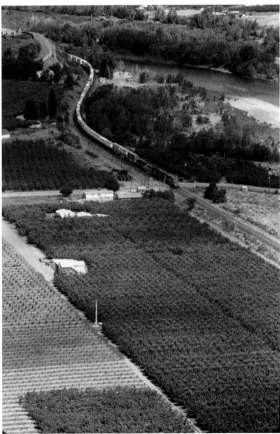

APPLE COUNTRY: The Wenatchee River flows out of the Cascade Mountains down into the Columbia Valley. Apples and other fruit from orchards over the years have made central Washington famous.

TUMWATER CANYON: The Great Northern followed the Wenatchee River up into the mountains through Tumwater Canyon, a rugged passage where the tracks were regularly blocked by rock-falls, floods and snow. In 1929, the railroad abandoned the line through Tumwater in favor of nearby Chumstick Canyon. Tumwater Canyon is now open to automobile traffic the year round on U. S. Highway 2.

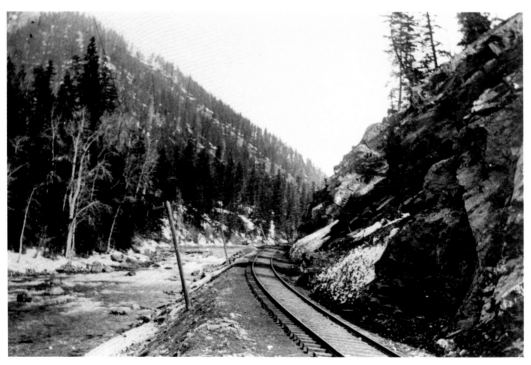

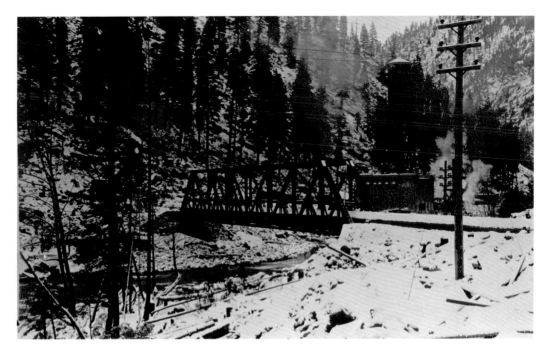

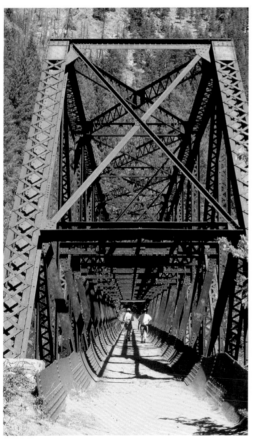

POWER PLANT: In 1909, the railroad built a small powerhouse just inside Tumwater Canyon to generate electricity for a set of electric locomotives—at that time, the latest high-tech railroad power. The advantage of electric locomotives was the absence of smoke, which often endangered passengers and crew riding through tunnels behind coal or oil-burning steam locomotives. Today, the power plant is gone, but the bridge and pathway that carried the water conduit from the dam—two miles upstream—survives.

THE NARROW CANYON: There were several places along the railroad in Tumwater Canyon where the roadbed made its way between the river and a steep cliff. Naturally it didn't take much of a snowfall before tons of the white stuff began sliding down onto the tracks. To handle the frequent slides, the Great Northern built snowsheds of heavy 12×12 and 12×24 beams. After the tracks were removed and the new Stevens Pass Highway was opened, the old sheds remained in place for some years. (*GNRHS*)

Snow Sheds 1674⁴, 1674⁵ and 1674⁶ looking east *6-27-'16*

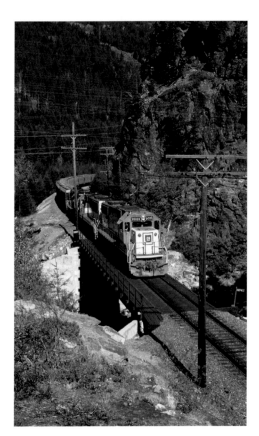

FOLLOWING NASON CREEK: At White Pine Road, the Great Northern rails, now deep in the Cascades, round a shoulder of rock while following Nason Creek. A few miles ahead is the east portal of the 7.8-mile Cascade Tunnel. (*Robert Oestreich photo*)

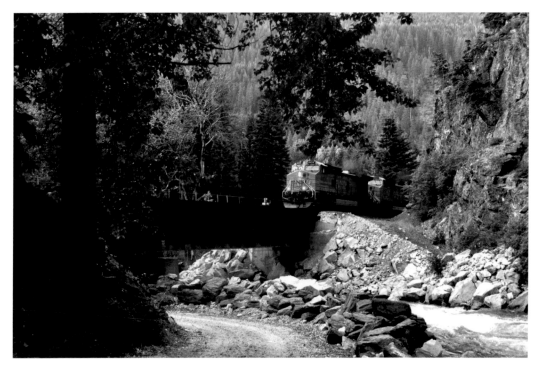

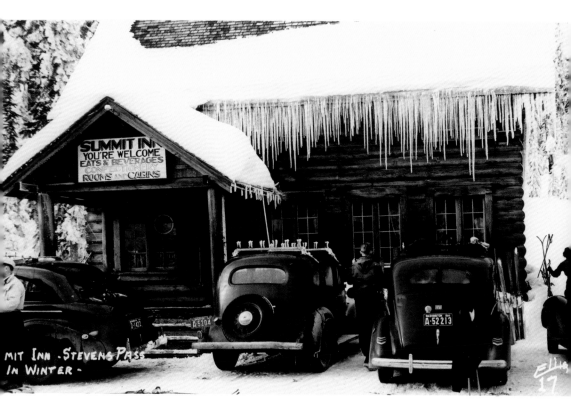

STEVENS PASS: Reaching the summit of Stevens Pass is an easy task on U.S. 2 today. In 1893, the railroad zigged and zagged a series of steep switchbacks on both sides of the mountain. It was a time-consuming ride, especially in winter, when the line often had to be cleared by rotary snowplows. In 1900, a tunnel was dug to eliminate the switchback route.

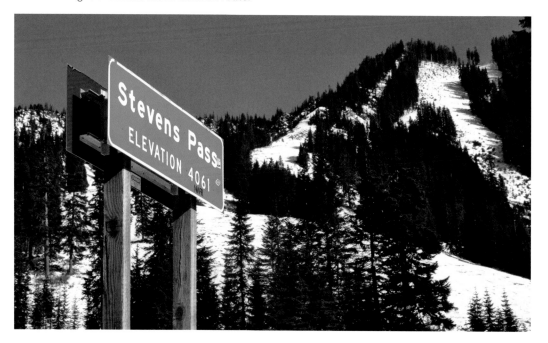

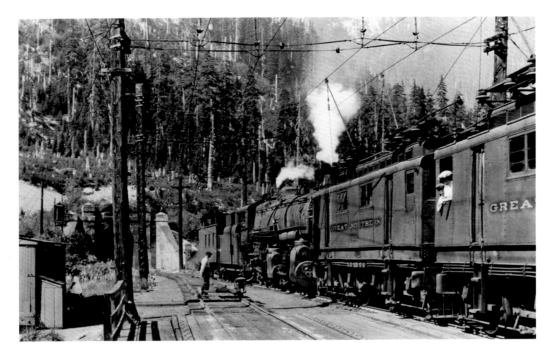

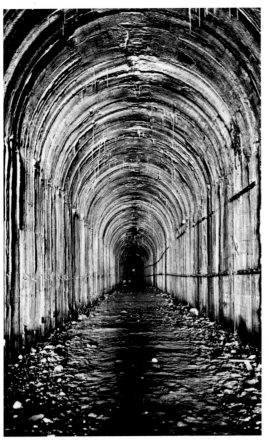

EARLY ELECTRIC LOCOMOTIVES:
The original electric boxcab locomotives
are shown exiting the east portal of the first
Cascade tunnel. The tunnel was abandoned
in 1929 when a longer tunnel was dug at
a lower elevation. In 2007-08, a partial
collapse of the hundred-year-old concrete
lining blocked the tunnel. Entering the
bore, even for photographs, is extremely
dangerous. (*Warren Wing collection*)

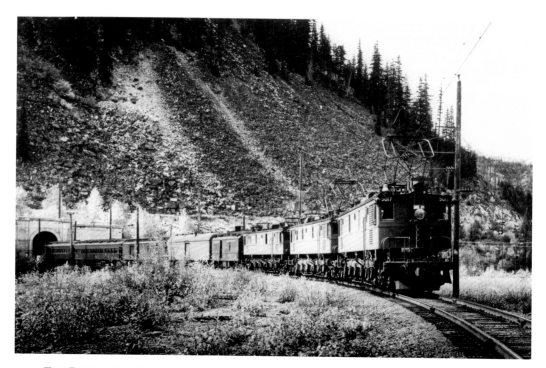

THE EIGHT-MILE TUNNEL: The second Cascade Tunnel, finished in 1929, was a great improvement for the Great Northern Railway and a first-class engineering marvel. Nearly eight miles in length, the tunnel allows rail traffic to bypass Stevens Pass. The second Cascade Tunnel held the record for length on North American railroads until 1988, when the Canadians opened their new tunnel under Rogers Pass on the Canadian Pacific.

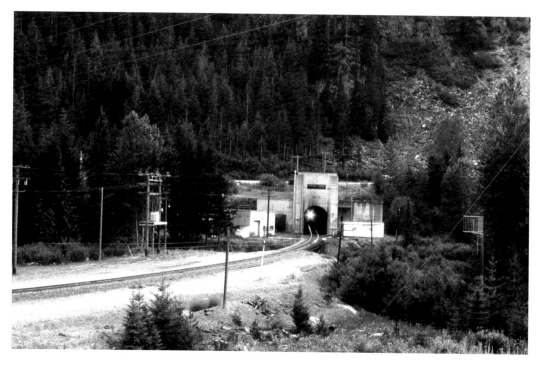

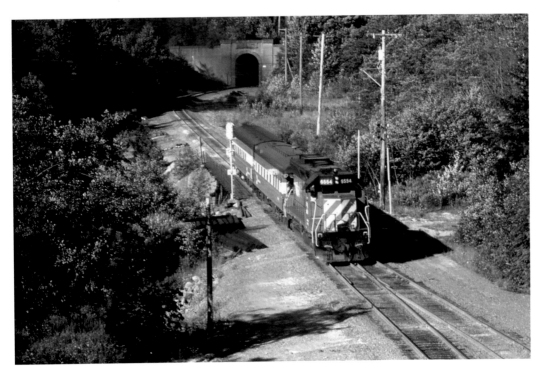

EMERGING FROM THE EIGHT-MILE TUNNEL: Electric locomotives in the original tunnel and the new eight-mile tunnel made it possible to move trains without making smoke that could asphyxiate passengers and train crews. The electrified zone was in use until 1956, when ventilating fans were installed that made safe passage through the tunnel possible without using special locomotives.

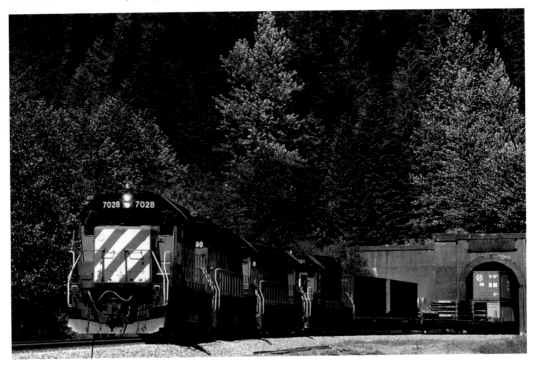

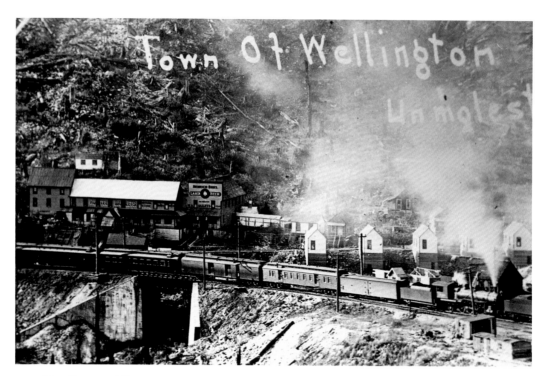

THE TOWN OF WELLINGTON: The west end of the original two-mile Cascade Tunnel opened out to the little railroad town of Wellington, which consisted of a few homes, a small school, a hotel, and the railroad shops and facilities. The town was abandoned in 1929 and the buildings removed after the new tunnel was opened. The massive concrete snow shed is still visible from U S 2 today, but is quite overgrown. (*GNRHS*)

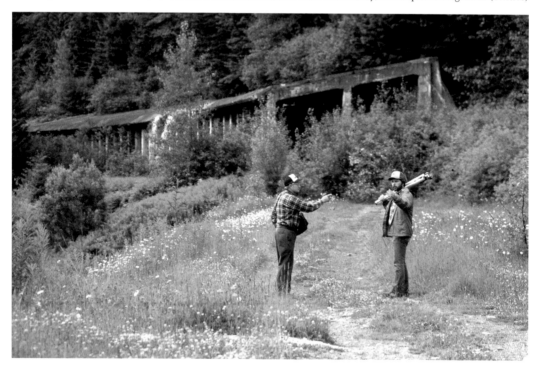

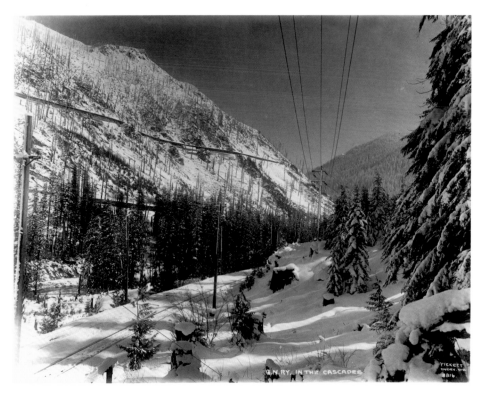

TRACKS ON THE MOUNTAINSIDE: On the west side of Stevens Pass, three levels of the original Great Northern mainline are visible in this 1929 photo by Lee Pickett. Pickett made photography of the Cascade Mountains and, especially, the Great Northern Railway, his avocation in the early part of the twentieth century. The original Great Northern mainline was later transformed into a spectacular hiking trail by the Volunteers for Outdoor Washington. (*GNRHS*)

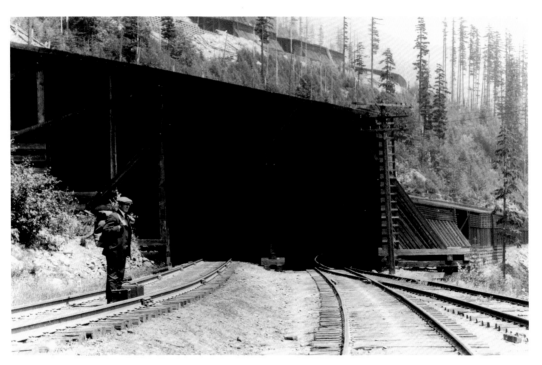

JAMES TURNER AT COREA SNOWSHED: Someone has said that the very concept of a snowshed bewilders the Eastern mind! Snowsheds, or snow galleries, have been around since the first transcontinental railroad was completed across the Sierra Nevada in 1869. Every winter, the sheds carry tons of avalanching snow over the tracks without incident. In spring and fall, the sheds carry rainwater and melting snow that would otherwise damage the track and roadbed. (*James Turner photo; Warren Wing collection*)

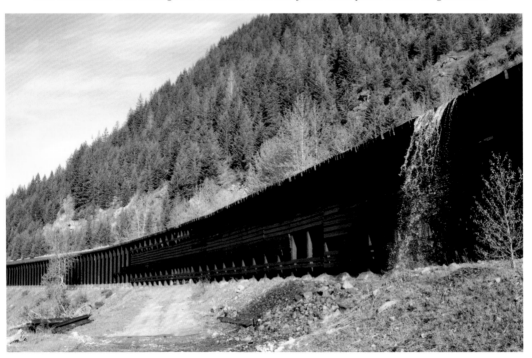

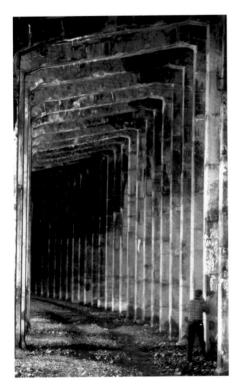

NOW A HIKING TRAIL: A long stretch of the original 1893 mainline west of Wellington lay abandoned for many years after the new tunnel was opened in 1929. The roadbed became overgrown and nearly impassable. Finally, in 1990, Volunteers for Outdoor Washington tackled the job of opening up the pathway to hikers. On their *Iron Goat Trail,* you can see the same mountain hillsides that travelers saw out the window of *The Great Northern Flyer* a hundred years ago.

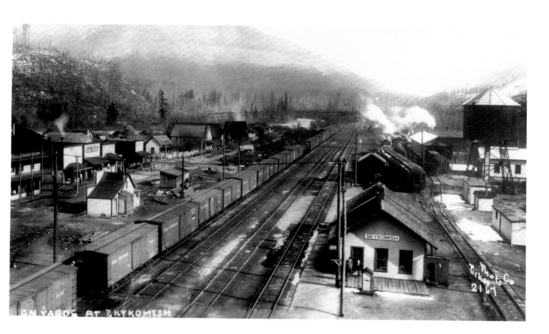

AN OLD RAILROAD TOWN:
The town of Skykomish, down from
Stevens Pass, is a former lumber
mill town and engine terminal
where helper engines were attached
to eastbound trains. Citizens have
recently restored much of the town
after surviving a major oil clean-up.
History-conscious town folk have
made Skykomish a latter-day
Brigadoon, with dozens of ancient
wooden homes and businesses. No
sign of urban renewal here! At the
depot, tourists are invited to ride the
small railroad that tours the old rail
yard area. (*Skykomish Historical Society*)

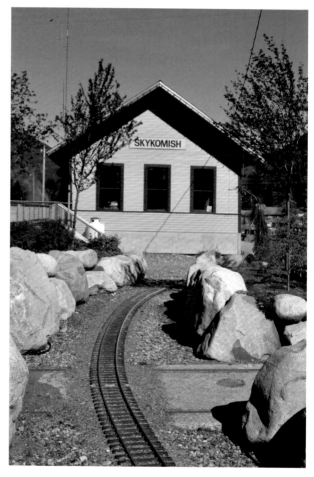

VIEW OF INDEX, WASHINGTON: In 1923, stonecutters from nearby Index Granite Company made the climb and carved the name "Lookout Point" on a rock overlooking the town of Index, Washington. In 2013, a one-hour climb was still the only way to see what the stonecutters saw: the town, the tracks, and 6,125 ft. Baring Mountain. (*Dave -Honan photo*)

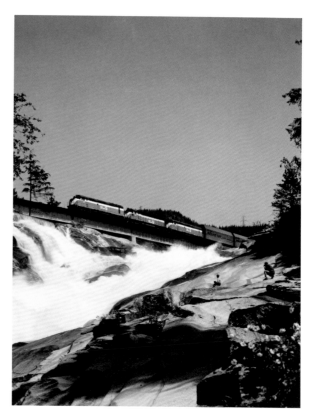

DRAMATIC SUNSET FALLS:
Sunset Falls, just east of Index, Washington, is unique in that the cascading water slides down a slanted rock face from one level of river to another. The bridge carries the mainline of the Burlington Northern Santa Fe and the daily Amtrak *Empire Builder*. The scene was featured in the 1969 Great Northern calendar, the last one to be published before the GN was merged with two other roads to form the Burlington Northern. (*GNRHS collection; thanks to Jeff Robertson for the dramatic night shot*)

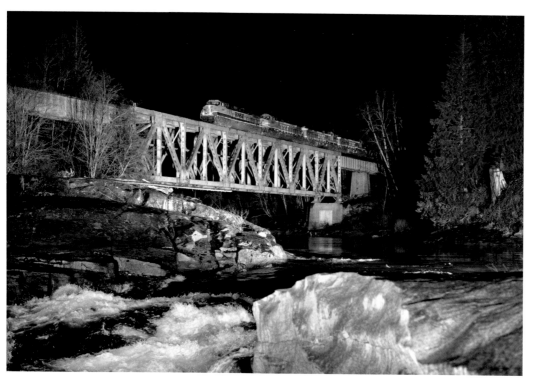

THE SEAWALL: The rails of the Great Northern reached the Pacific Ocean at Everett, Washington, and turned south to follow the shore thirty-two miles to Seattle. Steep hillsides along the way forced the roadbed right up against the water's edge. Track washouts were frequent. Storms and heavy surf did major damage to the line before 1906, when a great seawall was built to protect the rails and the roadbed. (*Robert E. Oestreich photo*)

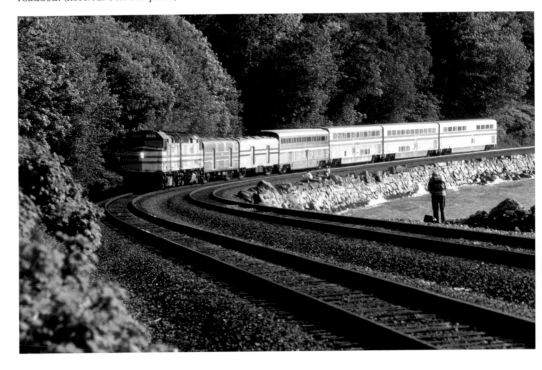

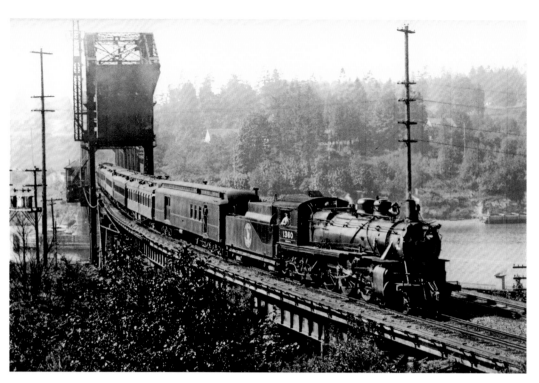

THE BRIDGE AT BALLARD: The Great Northern crossed Chittenden Locks, north of Seattle, on a fascinating steel drawbridge that could be raised to allow boat traffic to enter Lake Union. The bridge is still in use today. (*James Turner photo; Steve DeVight photo*)

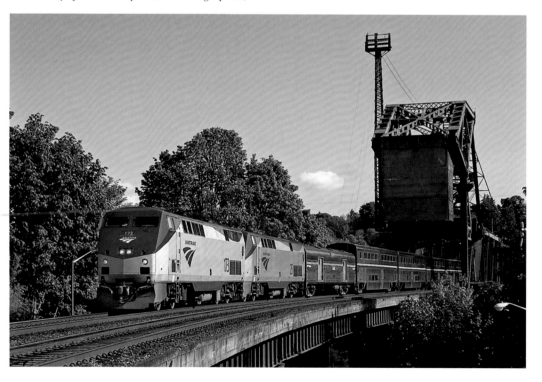

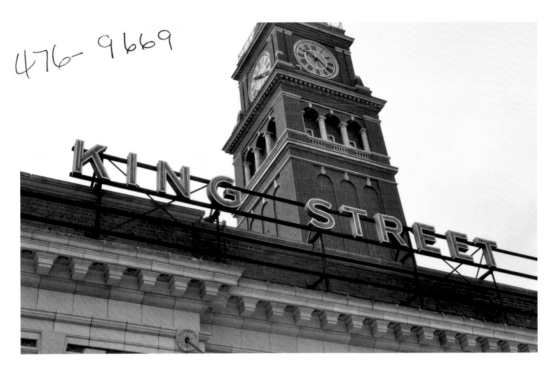

KING STREET STATION: The Great Northern depot in Seattle was built in 1906 and has been in constant use by rail passengers for over a hundred years. The railroad actually built a mile-long tunnel under the city to reach the depot site, located just south of the city center. The tunnel allowed the railroad to avoid running along the Seattle waterfront, separating it from the city. (*GNRHS; modern shot by Eric Williams*)

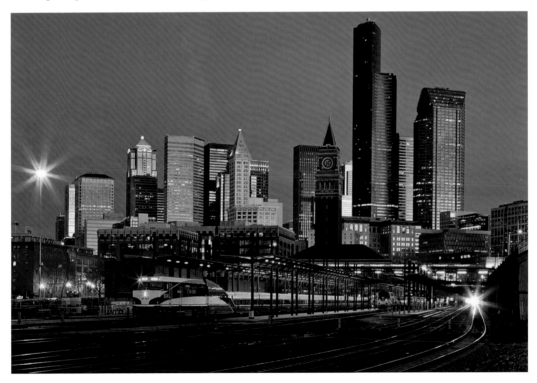

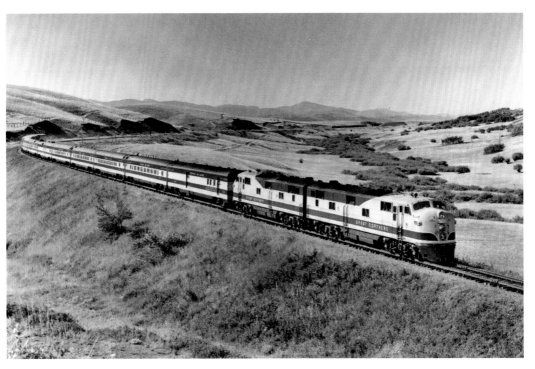

COMING AROUND THE BEND: The name and the excitement of Great Northern's *Empire Builder* continues. The 1947 version of the *Empire Builder* rounds the curve at Spotted Robe east of Glacier Park and heads across Montana and North Dakota to St. Paul and Chicago—more than 2000 miles along the way! Amtrak's *Empire Builder* carries a half million passengers a year—Amtrak's most popular ride! (*GNRHS*)

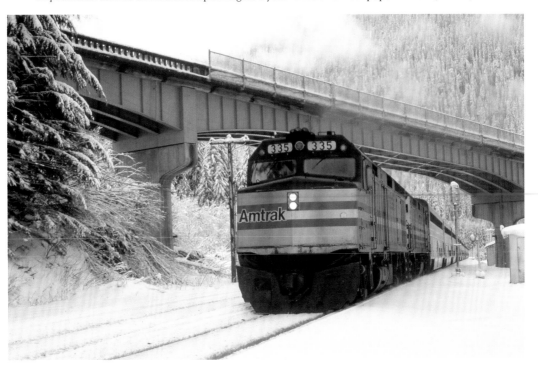

ACKNOWLEDGMENTS

The author wishes to thank the Great Northern Railway Historical Society for their aid in putting together this work. Their archives in Burien, Washington and St. Paul, Minnesota, were invaluable.

Thanks to the Historical Society of North Dakota, the Minnesota Historical Society, the Montana Historical Society, the University of Washington Libraries, and the Kandiohi County Historical Society in Minnesota.

Many of the recent photos were found on the website "Railpictures.net". The author wishes to thank the following makers for allowing their images to be used:

Don Delitz	Dan Kwarciany	Sean Kelly
Jeff Robertson	Shawn Christie	Mike Biehn
Bill Hooper	Steve Glischinski	Travis Dewitz
Bob Ball	Bryant Kaden	David Honan
Steve DeVight	Stan Short	

Thanks to Bob Kelly of Renton, Scott Tanner of Edmonds, and Don Pavia of Bellingham, Washington. Thanks to Warren McGee of Livingston, Montana, Chuck Hatler of Kansas City, Harold Hall of Springfield, Missouri, Phil Webb of Phoenix, Ron Euteneuer from Waite Park, Minnesota, Gary Nelson of Anoka, Minnesota, Larry Obermeyer of Sioux City, Iowa and Steve Reuter of Cincinnati for their assistance.

This book is dedicated to Casey Adams and Bob Oestreich of happy memory. They taught me the glory of the Northwest, the story of the Great Northern, and the joy of rail photography.